BARRON'S ART GUIDES

LEARNING TO
PAINT IN
watercolor

BARRON'S

Contents

watercolor

English translation © Copyright 1997
by Barron's Educational Series, Inc.
Original title of the book in Spanish is *Para empezar a pintar Acuarela*
© Copyright PARRAMÓN EDICIONES, S.A. 1996—World Rights
Published by Parramón Ediciones, S.A. Barcelona, Spain

Author: Parramón's Editorial Team
Illustrator: Parramón's Editorial Team

All inquiries should be addressed to:
Barron's Educational Series, Inc.
250 Wireless Boulevard
Hauppauge, New York 11788

Library of Congress Catalog Card No. 97-9413

International Standard Book No. 0-7641-0240-0

Library of Congress Cataloging-in-Publication Data
Para empezar a pintar acuarela. English
 Learning to paint in watercolor / [author, Parramón's Editorial Team ;
illustrator, Parramón's Editorial Team].
 p. cm. — (Barron's art guides)
 ISBN 0-7641-0240-0
 1. Watercolor painting—Technique. I. Parramón Ediciones.
Editorial Team. II. Title. III. Series.
ND2420.P29813 1997
751.42'2—dc21 97-9413
 CIP

Printed in Spain
9 8 7 6 5 4 3 2 1

T he main attraction of watercolor is the transparency of its colors, which create a fresh, luminous, spontaneous, and attractive painting. It is precisely this transparency that makes a watercolor painting not only enticing, but quite difficult to render.

The aim of this volume is to introduce the beginner to the watercolor medium. It has been designed in such a way that, little by little, the novice will acquire the fundamentals of watercolor painting so that he or she can paint with assurance and skill. Throughout the pages of this book, we will explain the materials needed to begin to paint, as well as procedures that, although quite simple, may seem a mystery for beginners, like how to mix colors, or how to use a brush. Included is advice on how to avoid errors. Techniques and tricks used by artists to create interesting effects are revealed. The book ends with several simple and clearly explained step-by-step exercises to encourage the student to learn quickly and effortlessly.

Once you have made the decision to try your hand at the captivating world of watercolor, you must always remember that nobody is born an artist. Even though your first attempts at painting may not be all that you hope for, if you carry on with patience and persistence, you will learn from your mistakes. Many of your early "failures" can be turned into triumphs that may be used later on to create textures or tackle new themes.

Paint

The main characteristic of watercolor paint is that it is used with water and applied on a paper support. But it also has another characteristic that distinguishes it from all other paints: the transparency of its colors.

The brownish particles accumulate in the small indentations of the paper's surface and produce a mottled effect.

Ultramarine particles, on the other hand, are drawn to one another and produce a more solid color.

Keep in mind that the gum arabic in the paint adheres upon drying. Therefore, it is recommended that the threads of the paint tubes be cleaned before replacing the cap, so that the top of the tube won't break the next time it is opened.

Composition of Paint

Watercolor paints are made up of ground natural pigments, binder agents such as gum arabic, which convert it into a solid mass, and moistening agents such as glycerin, which prevent the mass from drying and becoming too hard.

The pigments are the small particles that give the paint its color. Each pigment has a different origin; because of this, each one reacts in a different way. Pigments have greater and lesser dyeing capabilities; some are more transparent, whereas others are slightly opaque.

What You Can Buy

Watercolor paints can be purchased in three forms: dry, moist, and liquid. Depending upon its form, the paint is sold in cakes, tubes, and bottles.

TUBES

Paint that comes in tubes is moist because it contains a greater amount of moistening agents. This moist form of paint dries less quickly than watercolor paint in cake form. Tubes can be bought individually or in sets.

USES: Because tube paint takes longer to dry, it is recommended for slow-paced or detailed works. It is also ideal for painting large-format works because results are quicker and more effective. Large tubes also contain more paint than cakes.

ADVANTAGES: When a work calls for mixing colors, tube paint has the advantage of letting us mix one color with another to obtain a third without making a mess of the two initial colors, because the paint is not applied directly from the tube.

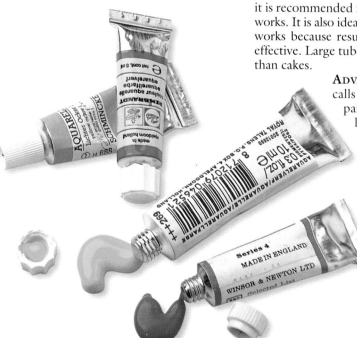

Quality and Recommendations

Working with good quality materials is important. Paint will spread more evenly; colors will be more uniform and will last longer. All of this results in a better painting. Nevertheless, there are paints on the market that have been especially designed for students and are more than adequate for beginners.

If you are just beginning to paint in watercolor, we recommend that you use cakes, because moist tube paint will dry on the palette. Cakes will let you paint directly and, because they can be displayed in an orderly fashion, will help you find what you want right away.

CAKES

Watercolor paints in cake form, also called tablets, are of the same quality as those in tube form. They are sold as a solid, and must be dampened in order to be used.

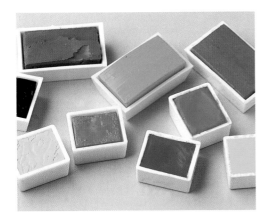

USES: This form is perhaps the most practical for the beginner who still does not know the names of all the colors or the amounts of paint necessary to complete a painting. Moreover, the small size of the cakes means that a small set can offer a great number of colors.

ADVANTAGES: The great advantage of the watercolor cakes is that we can see all the colors at a glance. Cakes are available individually or in sets in which the colors can be arranged by tones, separating cool colors from warm, if so desired.

DISADVANTAGES: When you remove a cake from it cellophane wrapping, you lose the name of the color. Therefore, we suggest you jot down the color's name so you know what to ask for when you need to replace it.

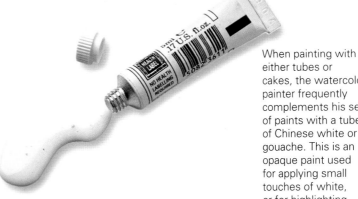

LIQUID WATERCOLOR BOTTLES AND DRY CAKES

You should be aware of the existence of these two types of watercolor paint, but it is not recommended to start off using them without prior experience, since they are not intended for fine art work or beginners.

On page 20 you will find information on the uses of these types of paint.

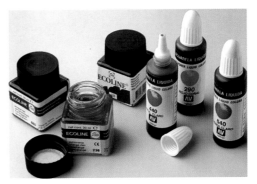

REMEMBER . . .

■ There is no reason to throw out paint that has dried on the palette, since you can use it again by wetting it with a paintbrush just as if it were a cake.

■ The gum arabic in the paint is a glue that sticks when it dries. To avoid having the cap stick to the tube, you should clean off the threads before replacing the cap.

■ When you open a newly purchased cake of paint, you lose the name of the color. We recommend that you take note of the name for later, when it's time to replace it.

When painting with either tubes or cakes, the watercolor painter frequently complements his set of paints with a tube of Chinese white or gouache. This is an opaque paint used for applying small touches of white, or for highlighting if the paper has been completely painted over.

BOTTLES
This type of paint comes in a liquid state and is more suitable for flat colors. Liquid watercolor is used more often by illustrators or graphic design artists than by watercolor artists. Bottles come in plastic or glass. Plastic bottles tend to be more practical since they often come with a dropper.

DRY CAKES
Dry cake paint contains little glycerin, so it is often difficult to wet. It might be necessary to rub the cake with a wet brush before it dissolves. Dry cakes are often used by schoolchildren; they generally don't spread color uniformly on the paper.

Paper

Paper is almost always used for watercolor painting. Watercolor paper has several unique characteristics that makes it the most suitable for working with a water-based medium.

Watercolor paper has what are called watermarks, or filigrees. These are nothing more than the manufacturer's trademark or logo. Originally, the mark was placed only on the face side, and was used to indicate which side of the paper should be used for painting. The proper side to paint on was the one that could be read correctly.

Pads with gummed sheets are ideal for those who don't want to bother with stretching the paper. The sheets are glued to the pad on all four sides, so the paper is always taut. To free the paper from the pad you need only slip a knife along one side and run it around the borders.

Materials

Watercolor

8

Composition and Characteristics

The principal characteristic of watercolor paper is its design for use in conjunction with a water-based medium. The paper has a porous surface that accepts and retains water. Watercolor paper is made of plant fibers that dilate with water, but, upon drying, revert to their original size. This last quality is very important.

Watercolor paper is made up of cellulose paste, glue, and cotton. A good-quality paper is made up of at least 50% cotton. The best papers are made entirely of cotton with no cellulose paste.

The truly unique aspect of watercolor paper is that it undergoes a special treatment. One side is treated in a bath of glue which forms a protective film, called the *prime coat*. The main purpose of the prime coat is to ensure that the pigment does not penetrate into the heart of the paper. If this were to occur, the colors would become flat and lose the brilliance that lends such a distinctive air to watercolor painting.

Watercolor paper is differentiated by its weight and by its texture, which can be hot pressed or fine, cold pressed or medium, or rough.

A paper's weight is determined by what 500 sheets weigh, which varies according to its purposes. A paper that weighs more than 140 lbs. does not need to be stretched while one is painting, unless the paper itself has been wet. Paper with a weight of less than 140 lbs. must be stretched to avoid buckling and warping.

What You Can Buy

Watercolor paper comes in separate sheets, in rolls, and in pads. Most individual sheets range in size from 22" × 30" to 40" × 60". Between these two extremes are various other sizes such as 10" × 14" and 30" × 40".

Rolls usually come 10 feet long by 44 1/2" or 51" wide. The great advantage of rolls, and at the same time their disadvantage, is that you have to cut them to size; therefore, you must always decide what size and shape you want to work with before starting out.

Pads come in a wide range of sizes. Some are as small as half a medium-sized sheet of paper. They can fit into a purse or pocket and can be taken wherever you go. The largest are usually about 22" × 30". The sheets of a pad may either be glued together on one side, or attached like a spiral notebook.

On page 26 you will find information on how to stretch paper.

REMEMBER . .

■ For beginners it is recommended that they use small-sized 90 lb. cold pressed, medium texture paper.

■ Paper lighter than 140 lbs. must be stretched to avoid warping.

Quality and Recommendations

Since it is likely that you will make some mistakes when you first start out painting with watercolor it is recommended that, for your first few attempts and until you become comfortable with the brush, you use paper made from wood pulp, which is much more economical.

Once you begin to paint compositions, as opposed to simply experimenting with techniques, you should use a medium quality paper. This is the type of paper generally used by students. Most are made with some amount of cotton—up to 60%.

It is best to work with a weight of about 90 lbs. This paper is light and needs to be stretched because it warps easily. Although this might seem an inconvenience, it is actually to your advantage, since it is important to get accustomed to painting correctly from the outset.

The best paper sizes to use to get started in watercolor painting are the smaller ones, such as 7" × 10" and 22" × 30" half-sheet pads. Of course, you can start painting on a whole sheet, but if you haven't mastered proper brush control, and you still haven't learned how to distribute color, then chances are the use of large-sized paper will cost you more than you anticipated.

Types of Surface and Texture

When you buy paper, you will have to decide what weight and surface texture you prefer. Regarding texture, you will have to figure out for yourself which best suits your taste. You should be aware that for beginners the best is a cold pressed, medium texture paper.

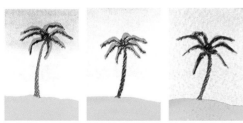

The same motif has been painted on three types of surface: hot pressed (fine), cold pressed (medium), and rough. The texture of the paper plays a significant role in the outcome of a painting.

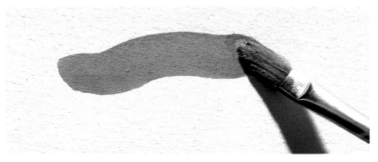

Hot pressed paper has a smooth surface. This paper is suitable for a painting that is based on a detailed drawing or for a small painting. However, this type of paper might not be the best for the beginner, because without surface barriers, the paint runs and bleeds a lot. Another problem is that this paper makes the paint dry more quickly than a rougher textured paper and, if your style is not yet developed, you will find that you will make breaks, or overlaps, in your painting.

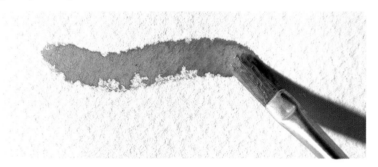

Cold pressed paper has a medium texture that is more suitable for someone just beginning to paint in watercolor. The medium texture is not extremely rough, it holds up well when wet, and it is good for painting on any size paper. However, the paint will bleed over the boundaries of where you want to paint if you push down on the brush too much.

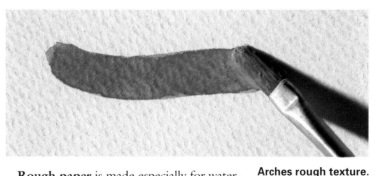

Rough paper is made especially for watercolor painting. It is the paper generally used in large sizes. The indentations of its distinctive pebbled surface allow the paper to hold up well when wet. The uneven surface is, nonetheless, a hindrance for those who are inexperienced in watercolor. The contours of the paper make tracing a line difficult, so it is hard to make a preliminary drawing on its surface.

Arches hot pressed. This paper is made of 100% cotton. It has a good absorption rate and withstands both surface pressure and retouchings.

Arches cold pressed. This paper is made of 100% cotton. It lets the pigment spread easily, but maintains a clean line.

Arches rough texture. This paper also is made of 100% cotton. It is considered one of the best papers produced by the Arches company for the perfection of contours because it allows the pigment to spread.

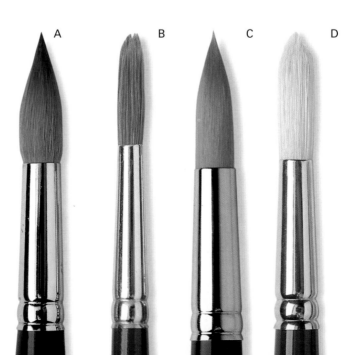

*B*rushes

The fibers

The ferrule

The handle

The brush is the tool used to apply paint to paper. Basically, the differences between brushes are in size, the shape of the bristles or hair, and the type of fiber used in the brush. Each brush has its own distinct use. As a result, the success of a painting often depends upon the correct choice of brush.

Structure of Brushes

There are three distinct parts to a brush: the handle, the ferrule, and the bristle.

The **handle** is the part of the brush that the artist holds.

The **ferrule** is the metal sheath that gathers the bristles and joins them to the handle.

The **fibers** are the part used to apply the paint. Each brush type creates a different style of application. The best type of watercolor brush is made of sable hair because sable hair absorbs the most liquid, paints the most exact line, and retains its original shape the longest.

Unfortunately, sable hair brushes are very expensive. Similar results may be obtained with ox hair brushes. Ox hair is much cheaper than sable hair; and although it does not form as good a point, it still makes a good substitute.

Ox hair brushes are made of hair from the animal's ear. This type of hair is brown and holds paint well.

Synthetic fibers, made from special filaments, are another good alternative to sable hair. Because such fibers are not natural, they do not hold and retain a lot of paint. On the plus side, synthetic fiber brushes paint very accurately, are very resilient, and always return to their original form.

Hog's bristle is the least expensive animal hair brush on the market. In watercolor it is used solely to make corrections or to fill in backgrounds. There is a Chinese hog's bristle brush that has been treated to make it incredibly soft. A brush of this fiber retains a large quantity of paint. Wide brushes made of this hair are used for painting large washes.

On page 22 there is information on how to use a brush and which types are most appropriate for beginners.

A
Sable hair brush

B
Ox hair brush

C
Synthetic bristle brush

D
Hog's bristle brush

A B C D

Round brushes.

Brush Types

Brushes can be round or flat. Although some artists prefer a flat brush, watercolor painting is more often done with a round brush, which is more versatile.

Within the range of flat brushes there are certain types that are distinguished by the form of their hairs.

Flat tipped brushes have hairs that are all the same length, and are perfectly aligned. They are used to profile outlines and to flatten paint.

Filbert brushes have short hairs that form a soft curve. This type of brush functions like a flat-tipped paintbrush if you put the ferrule parallel to the paper, and like a round bush if you rotate it while painting.

Wide brushes have a wide, flattened, and longer neck. They are used for backgrounds and large washes.

Brush Sizes

All brushes have a number on the handle that indicates the diameter of the ferrule, and with it, the thickness or fineness of the hair. The numbers follow an international standard used by most brands of brushes. Its purpose is to standardize sizes, so that painters know exactly which brush they are working with, and which they will need. Generally, the numbering starts at 000, corresponding to the finest brush available, and ends at 24, which is the thickest.

Brushes size 000, 12, and 24 (actual size)

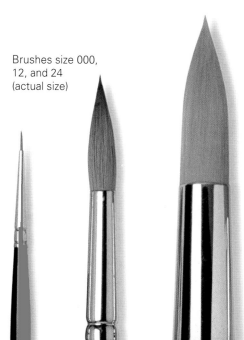

Quality and Recommendations

As we have already mentioned, the highest quality brush available is made of sable hair. The scarcity of this type of hair makes thick sable hair brushes exorbitant in price. Because of this, many artists only buy small-sized sable hair brushes, that is, very fine brushes. For thicker brushes, there is the option of ox hair or synthetic fiber.

When you are just learning to paint, the ox hair brush is the most suitable, since it works very well with watercolor paint, and it is economical.

REMEMBER . . .

■ The round brush is the most versatile; this makes it more practical for water-color painting.

■ Synthetic fiber and ox hair brushes are good substitutes for sable hair brushes.

■ Wide brushes are auxiliary brushes used to cover large areas, such as backgrounds.

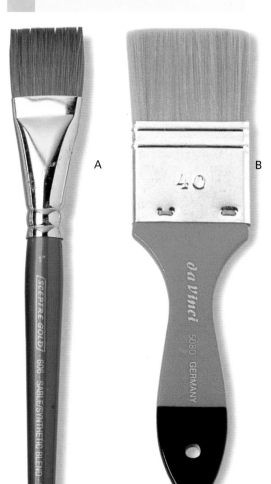

A

B

C

A
Flat-tipped brush

B
Wide brush

C
Filbert brush

Boards, Easels, and Paint Boxes

Even though all you really need for watercolor painting is paper, a brush, and some paints, you will require some other things if you want to go about this medium properly. Among these are a drawing board, an easel, and a paint box. Of course, you could do without these items, but keep in mind that you will be a lot more comfortable if you paint with them.

Boards

Board sizes depend upon the size of paper you want to work with. Your board should always be 2 inches larger on each side than the paper.

Boards are used to attach and support the paper. You should count on having more than one board, because this will allow you to work on more than one painting at a time. In addition, if you decide to stretch wet paper, it will be essential to have more than one board, since paper takes hours to dry. With many boards you can prepare various sheets of paper for painting the following day. Boards should be made of wood and be sufficiently heavy so they won't bend or break under the tension of the drying paper.

It's good to own various boards in order to be able to work with more than one painting at a time. You should have available various sizes of drawing boards, such as 22" × 30" and 29½" × 40", which correspond to standard sizes of paper. (Keep in mind, however, that if you are just learning to paint in watercolor, we have already recommended that you use smaller sized paper, such as 12" × 14".)

Unless you paint on small sized paper (using, for example, 10" × 12" boards for 8" × 10" paper) the board must be at least ¼" thick so that it is sufficiently strong.

Easels

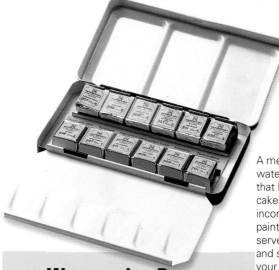

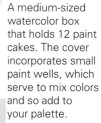

An easel is a wooden structure that supports the board or frame.

All easels have a system of pins and holes that allow you to adjust the height and inclination of your drawing board as you see fit. Adjusting the proper angle of the paper is particularly important in watercolor painting.

There are various types of easels for watercolor painting. Perhaps the type most suitable for the beginner is one of the folding types. This easel is very light and can be carried and stored easily. Easels also have two small mounts to support your paint box.

If you are thinking of painting outdoors with an easel, bear in mind that no matter how well made the easel is, it will never be completely stable. There is always the risk that a gust of wind will make it topple over.

For painting indoors, small easels without legs are also available. They are designed to sit directly on a table. Book rests and music stands may also work well if they have an appropriate angle of inclination.

Watercolor Boxes

A medium-sized watercolor box that holds 12 paint cakes. The cover incorporates small paint wells, which serve to mix colors and so add to your palette.

A metal watercolor box for 12 tubes with a folding double palette.

Art supply stores sell luxurious wooden boxes for carrying and keeping your paints and brushes. Nevertheless, when the time comes to paint outdoors, these cases may turn out to be impractical, since there never seems to be enough space for water jars, rags, pencils, and the like. If you are thinking of buying a box for your watercolor paints, we advise you to choose the most practical type, such as a metal watercolor box with a palette built into the top. If you want to paint outdoors, the other painting tools you want to carry along can be stored easily in a bag, along with a folding easel.

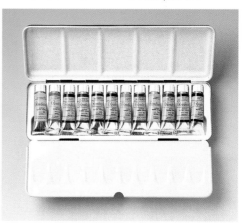

Seats

One should not generally paint while seated, since it restricts mobility and affects the freshness of the stroke. In spite of this, some artists feel more comfortable when they are seated. In the studio you can use whatever chair is at hand, or one which you feel most comfortable with. Some artists prefer a stool to a chair. When you want to paint outside, an outdoors seat or a simple chair used for camping is best. In any case, it is recommended that the seat be of the folding variety so that you can carry it with you easily.

An outdoor folding chair is completely flat when folded away. It is ideal for putting into a large paint box.

Jars, Wells, and Palettes

Water jars, palettes, and paint wells are the containers used to hold water for dissolving paints and washing brushes, mixing colors, and holding a sufficient water supply, all of which is essential when painting in watercolor.

Round paint wells look like this, without nooks or crannies where undissolved paint can accumulate. This makes it easier to mix the paint thoroughly with water.

Water Jars

Water jars are placed within reach, so they can be used to dissolve watercolor paint and to clean brushes each time you change color.

Water receptacles can be made of either plastic or glass. Obviously, plastic does not break, but some artists prefer glass. It is important that the water jar holds a pint to a quart of water because, when cleaning brushes, smaller amounts of water will rapidly become cloudy with paint.

Jars must have a wide mouth to make it easy to wet and clean brushes.

Paint Wells

Paint wells are small receptacles in which paint is dissolved in water to create a specific tonal value that we want to maintain throughout its application. You will find them in art supply stores, but you can also use any small containers you may have around the house. Paint wells come separately or in trays.

This practical tray combines two types of wells, a useful feature if you want to play with different densities of paint. The round ones are used for paint that is more watery, while the rectangular compartments are used for more viscous paint. The rectangular paint compartments make it easier to control the amount of paint you put on the brush because paint accumulates at the deep end, and the inclined bottom helps to wring out the brush.

Two different types of water jars. They should hold between a pint and a quart of water and have a wide mouth.

Palettes

A palette is what artists use to mix their colors on. There are many types—you will have to decide which kind you will want to work with, or which best suits your needs. Watercolor palettes are manufactured, or covered, with a material that repels water and lets it move around freely, so that the paints can mix well. A palette can be equipped with a hole that you put your thumb through for support, or, as with paint boxes, with a ring. Palettes are usually made of enameled metal, ceramic, or plastic. They are usually white, so the colors you place on them are not distorted. Large palettes have a large number of wells to hold colors, and areas for mixing colors that are divided into compartments. This is ideal when working with cool and warm colors that you do not want to mix.

PALETTE BOXES

Palette boxes are used when using watercolor paint from tubes. These metal cases are coated with a white enamel, and are supplied with a ring so you can support them with your thumb. They have a section divided into paint wells. Palette boxes come in many shapes and sizes, some having more space for the well areas and others more space for the palette. They are very practical to carry and preserve the dried paint that is left over after each session. They are also helpful in keeping the colors in perfect order.

If you don't have a palette in the house, there are many things you can use. A porcelain plate is perfectly suitable for mixing and holding your colors, and the slope of the edge is ideal for wringing out the brush.

The simple plastic egg carton can be converted into a practical tray of paint wells.

A large palette like this makes your work easier if you are going to use a lot of colors or different values. The hole is built in for your thumb to slip through, making the palette comfortable to hold in your hand.

This case has a large number of individual compartments. The tops are designed to be used as palettes. The size of the case makes it quite manageable, as well as practical, since it has such a large capacity. Its design incorporates a ring for the thumb.

REMEMBER . . .

■ Any impermeable surface can serve as a palette for watercolor painting.

■ It is advisable that water jars hold more than a pint, so that the water does not get dirty too quickly.

■ It is recommended that the palette be white so that its color does not distort the range of paint colors.

Additional Useful Products

There are a number of products that are not essential for watercolor painting, but can make the work of the painter much easier. Some of these substances are added to the watercolor solution and others are used to treat the painting. One of these products is designed to preserve, or "reserve," parts of the painting and others are used to fix the painting.

Gum arabic is sold in art supply stores in liquid form.

Masking fluid available on the market can be either colorless or tinted.

Masking Fluid

Masking fluid is a creamy solution of natural latex and ammonia. When spread over the paper it forms an impermeable film that protects the paper from paint. This product allows the artist to preserve areas of white paper, and to suggest a brightness or sparkle; it can even preserve sections that are not white.

Since the film does not let in water, the artist can apply the paint freely over the masked area, knowing that the details will be protected.

Masking fluid is easily removed from the paper by gently rubbing it with a finger or, better still, with an eraser. In spite of this, we suggest that you not leave it on for long periods of time, since it becomes harder to remove as time passes. You may end up ruining the paper when you finally try to take it off.

We advise using an old brush to apply masking fluid, because the fluid can damage the hairs. You can also spread it on with a nib if the part to be masked is a fine line or a small detail.

On page 43 you can find more information on the uses of masking fluid.

Gum Arabic

Gum arabic is one of the main components of watercolor paint. It acts as a coagulant for the pigments.

It is used for various purposes. If you add a squirt of gum arabic to the water used to mix paint, it will take away the paint's fluidity, and give it more body and consistency. This will increase the brilliance and transparency of the colors. You can also add gum arabic directly to the paint to obtain a thicker application, but you then run the risk that the paint will crack after drying, when the paper is handled.

Gum arabic can also be used as a masking fluid, since it does not allow the pigment to fix itself on the paper.

Gum arabic produces a shine when it dries and it can be used as a recourse to revive the colors of some areas of a painting that seem a little flat. It is applied as a fine coat over the painting once the paint is dry.

Medium

A watercolor medium is a mixture of gum arabic, acetic acid, and water.

It is dissolved in the water used to paint—a few drops per quart—to eliminate possible grease remains, giving the paint more intensity, brilliance, and transparency, as well as to increase the adhesive quality of the paint.

It is advisable to use watercolor medium when you have worked a lot with lead pencil to lay out the drawing on the paper and it is likely that you have left grease marks from your hands on it.

Medium also can be mixed directly with paint to thicken it.

Ox Gall

Ox gall is a wetting agent that changes the surface tension of water. It is used to modify the paint's drying time. If used in the winter, paint dries more quickly; if used in the summer, the drying time is prolonged. It also helps to increase the fluidity and adherence of the paint.

Ox gall is used when painting in dry places or, in the summer, to prevent water from evaporating too rapidly and creating breaks on the surface of the painting.

On page 30 you will find more information on breaks and how to avoid them.

Ox gall usually comes in small glass bottles.

Varnishes

Varnishes are used to protect colors and they inevitably give the painting a light shine. Some watercolor painters do not like this result, since the work loses its characteristic matte appearance. Other artists only apply varnish to certain areas of the painting, darker areas, for instance, to soften the contrasts. Varnishes come in liquid form, and are applied with a brush after the watercolor paint has dried thoroughly. You should pay attention to the amount of varnish applied, because a coat that is too thick gives the painting a plastic appearance. You should also pay attention to the pressure you exert on the brush. Pressing down too hard might remove the paint slightly and muddy some colors.

Varnishes also come in aerosol cans. This form might be more practical because the amount you apply is easier to control, and you can thereby avoid too much gloss.

Varnish is a liquid applied either with a brush or with an aerosol can.

Other Materials

All of the materials mentioned in this section are useful for painting in watercolor. It is important to become familiar with them because some will become essential during the painting process.

A. A **right triangle** has two 45-degree angles.

B. A **30/60 triangle** has 30-, 60-, and 90-degree angles.

C. A **ruler** is used to draw straight lines and to cut paper. For this reason, it is recommended that the ruler be made of metal.

Drawing and Erasing

Pencils. Grease-based drawing material can never be used for sketching, since wax is incompatible with water. Otherwise, every artist has his own preferences. Generally, soft graphite pencils are used, a number 2, HB, or B. Some artists, nonetheless, prefer harder pencils so that the lines remain less visible. Other artists, facing the same problem, lightly erase the lines before beginning to paint. See page 28.

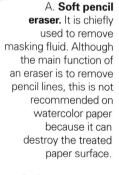

A. **Soft pencil eraser.** It is chiefly used to remove masking fluid. Although the main function of an eraser is to remove pencil lines, this is not recommended on watercolor paper because it can destroy the treated paper surface.

B. **Artgum eraser.** This is the softest form of eraser. It does less damage than other types to the treated paper surface. It is the preferred type of eraser for erasing on watercolor paper.

Erasers. Aside from being used to erase, erasers are used to remove masking fluid. See page 43.

Rulers, right triangles, and 30/60 triangles. These are used to draft, to trace straight lines, to resolve perspectives, and to draw commonly used angles. They are quite useful for making a grid when copying from a photograph. See page 28.

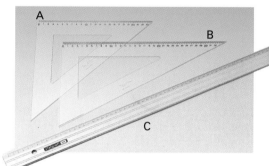

Absorbing and Cleaning

Rags. Cotton rags are the best, because they are the most absorbent. They are used to absorb excess water in brushes, to dry hands, and even to make corrections. See page 22.

Paper towels or tissue. They are used to wipe up paint, make corrections, and absorb excess liquid. See page 44.

Drying paper. This is basically used to absorb excess liquid on the paper, make corrections, and create special effects. See pages 44–45.

Attaching and Cutting

Gummed paper tape. It is a special type of tape that is used to stretch the paper for watercolor painting. One side has glue that must be moistened for it to adhere. Although annoying to work with, it is the only type of tape that can stick to paper when the paper is wet. See page 26.

Tacks. They are used to fix or stretch the paper on a drawing board.

Scissors. They are used to cut the paper. It is preferable that they are well-sharpened, and long enough to work with easily, and make a continuous, straight cut.

Utility knife. This type of knife is used to cut paper, and also to open up white areas on the paper. See page 45.

Effects and Techniques

Knife. A knife is used to open up white areas and to create special effects. See page 45.

Cotton swabs. They are ideal for making corrections and opening up white spaces.

Wax pencils. Because wax is incompatible with watercolor paint, wax pencils are used to keep spaces blank or to create shadows. See page 43.

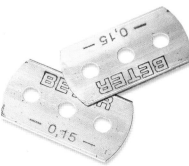

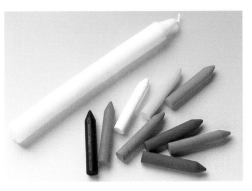

Nibs. They are used to outline forms already painted or to give body to details already rendered in the painting.

India ink. This is found in bars for pencils, and in liquid form for nibs. It is used to outline forms both before and after painting.

Fixative. It is used to fix colors once the painting is dry.

Roller. It is used to paint backgrounds and to create effects. See page 51.

Sponges. These are tools with multiple uses. Sponges are used to dampen the paper, absorb excess liquid, open up white spaces, and function as a complement to the brush. See page 51.

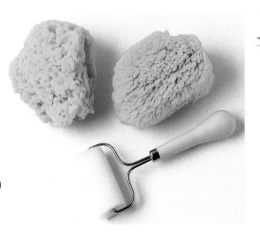

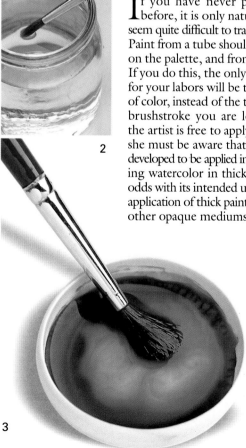

TUBE
1. In order to prepare a wash with moist paint from the tube, you must squeeze out a little into a paint well or saucer.
2. Dip the brush in water.
3. Work the paint until it is completely diluted. Test the color on a piece of the same type of paper that you are going to use for the painting. If the color is still too intense, continue adding water and repeating the operation until the color reaches the intensity that you wish.

How to Use Paint

Although painting in watercolor may appear easy, it can be an unknown quantity for the beginner if he or she has never before been exposed to it. In this chapter, you will discover that, although mixing paint with water seems like simplicity itself, there can be problems if you are unfamiliar with the process.

Mixing and Diluting Watercolor

If you have never painted in watercolor before, it is only natural that, at first, it will seem quite difficult to transfer paint to the palette. Paint from a tube should not be placed directly on the palette, and from there onto the paper. If you do this, the only results you will obtain for your labors will be thick and opaque blobs of color, instead of the transparent and brilliant brushstroke you are looking for. Naturally, the artist is free to apply thick paint, but he or she must be aware that this medium has been developed to be applied in a certain way, and applying watercolor in thick coats is completely at odds with its intended use. The truth is that the application of thick paint is more appropriate for other opaque mediums such as gouache.

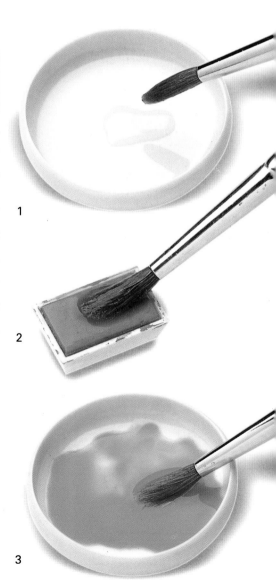

CAKE
1. If you are going to paint using cakes, put some drops of water in the paint well first.
2. Next, with a wet brush, rub the cake, drawing some pigment into the hairs.
3. Swirl the brush in the water well. Keep testing the color on scraps of paper and adding more paint until you achieve the color you desire.

Similarly, if you try to work painting directly from paint cakes, you will soon discover that they will soften and become viscous, and will be used up very quickly.

Watercolor paint has to be transferred first to a paint well or to a palette. Then, it is diluted in water to create the different washes. To begin painting correctly, the paint must be in a solution of water. These solutions are called *washes*. A wash is also an application of rather diluted paint of one color, so don't get confused.

Mixing Paint on a Palette

Naturally, not all colors and values that you intend to use will be made by washes in paint wells. Generally, the colors that are prepared in paint wells or compartments are those that you will use to cover large areas of the painting. If you only intend to use a color for a small area or for some detailed work, the paint is mixed directly on the palette.

To dilute paint on a palette you must first transfer it over. In the case of moist tube paint, you can squeeze it directly onto the palette. However, it is best to squeeze out a small amount onto a nearby surface and then bring it over to the palette with the brush, as is done with a paint cake.

In order to take pigment from a paint cake, you only have to wet the brush and softly rub it over the cake. The cake softens up and paint is drawn into the hairs. When the brush is loaded with paint, apply it to the palette—you will see for yourself how easily the color is transferred to the palette.

Mixing Colors

The same procedure is used for mixing colors. First put one color on the palette using the technique described above, then add another, making sure to clean the brush first.

The mixture must always be made first on the palette or paint well. The brush must be washed each time a different color is chosen so that the paint cakes or the moist paint are not muddied.

With use, the palette becomes quite dirty and you end up with a surface covered with stains of color. You can use it like that, or clean it after every use—that is entirely up to you. Bear in mind that, if you do not clean the palette, the colors will always be a little contaminated with old washes and you won't have fresh, pure colors. This is not necessarily bad; many professional artists prefer this, in order to give their works a more homogeneous tone. Some have not cleaned their palettes in years.

■ The brush must be clean before transferring color to the palette or well. Bear in mind that, if you do not clean your brushes first, the paint cakes or the portions of moist paint that you have deposited in the wells of your palette will become muddy.

■ The solutions of water and paint that are made in the paint wells or saucers are called washes, although the term wash is also used in a general way to connote a painting of only one color, or the application of very diluted paint on paper.

■ You should not apply paint directly from the tube or paint cake onto the paper because it is essential for it to be diluted in water in order for watercolor to flow and maintain its transparency.

Different colors are worked onto the palette. You will take more of one than of another, depending on the tone and value sought.

Once watercolor has been transferred to the palette, you must add a small amount of water with the brush and work it in with a circular motion, so that paint particles are dissolved.

Test the color out on a piece of paper until you have the color you want. Do not forget that watercolor paint loses 15% of its intensity when it dries. You should keep this in mind when you are diluting the paint and choosing the tone.

How to Use a Brush

Don't paint by flattening the bristles over the paper or applying the brush with too much force. You need to hold the brush lightly but firmly in order to control the pressure that the hairs bring to bear upon the paper because this will determine the thickness of the strokes and the amount of paint that flows onto the paper.

A brush is the instrument with which we apply the paint onto the paper. To create a good rendition on paper it is important to know how to handle it properly, to know how versatile it can be, and how to maintain it in good condition.

How It Is Held

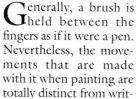

Generally, a brush is held between the fingers as if it were a pen. Nevertheless, the movements that are made with it when painting are totally distinct from writing. The hairs of a brush are much more versatile than the point of a pen, and so a brush is manipulated in all directions to create a myriad of different effects, all of which depend upon how the brush is moved, and the pressure that is applied.

Watercolor is a fresh and loose form of painting that requires a light hold on the brush. In other words, you will need to practice manipulating a brush until you can hold it freely and control it with a soft touch.

Unless you are going to paint some details that require you

The brush should be held more or less in the middle of the handle. If you become accustomed to holding the brush nearer to the end of the handle you will gain a freedom and rapidity in your motions.

to exercise control over your own stroke, you should not become accustomed to painting by holding onto the brush by the ferrule. You lose agility that way, the brush becomes less versatile, and your stroke more awkward.

When you have to paint details, you will begin to realize that it is not as simple as you may imagine to control the stroke. So that your hand does not shake, and so that you can paint with precision, we suggest that you support the little finger of the hand holding the brush by resting it on the paper. In this way, you will be able to control the force and direction of the small stroke, and you will ensure that the brush does not paint where it shouldn't.

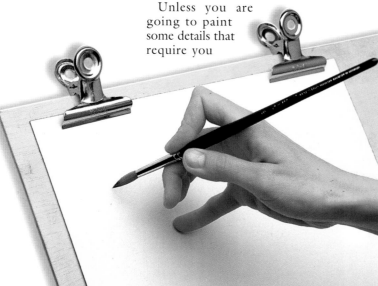

When you get ready to paint it is essential that you always have a rag at hand. The brush will often have too much water or paint than you would like. To avoid putting too much paint on the paper, which will produce drips and pools, it is advisable to let the excess soak into a rag. A rag made of cotton is the most suitable because it is absorbent. Keep in mind that a rag is also more ecological than paper towels, and it won't fall apart when wet.

How Many Brushes Do We Need?

Professional painters usually work with few brushes because a good brush is easily handled, is quite versatile, and much can be done with it. Of course, an artist that works with small refined strokes, and takes care of details won't use the same type of brush as another who prefers loose, sweeping, energetic strokes.

For beginners, four types of brushes will be more than sufficient.

1. A wide Chinese hog's bristle brush.
2. A number 8 ox hair brush.
3. A number 4 ox hair brush.
4. A number 2 sable hair brush.

You will need a wide brush to make large washes. You can acquire one made of soft squirrel hair or one of synthetic fiber. For detailed work, a number 1 or 2 brush is the most appropriate. This size of brush has to be able to mark precisely, so it is best if you choose one of sable hair or of synthetic fibers.

For general painting, two sable hair or ox hair brushes will be good enough. Regarding the size of the brush, a number 14 is the most popular; as a complement to this, you could buy a number 8.

REMEMBER . . .

■ You should not hold the brush by the ferrule because you will lose freedom of movement.

■ Never leave brushes standing on their fibers in water for long periods of time.

■ When leaving a brush on a table make sure that its fibers are not pressed against something that could deform them.

■ Do not let paint dry in the fibers because you run the risk that they will lose their form.

■ After washing your brushes, make sure their fibers are not out of shape, manipulating them back into shape if necessary.

■ A well-cared for brush facilitates your work and will last for years.

How to Wash Brushes

It is important that you wash your brushes every time you finish painting, so that the hairs do not lose their form or deteriorate.

Being a water-based medium, watercolor paint dissolves easily with water and you do not need solvents to clean the brushes.

Avoid washing the brushes in hot water, since this could soften the glue that holds the bristles to the ferrule. The brush will begin to lose its fibers and, consequently, will be ruined over time.

All you really need to do is use a little mild laundry soap.

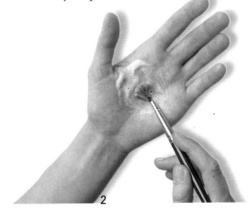

2

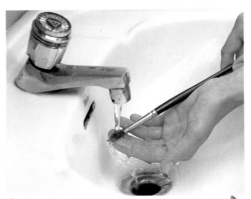

3

How to Care for Brushes

If you paint often, after washing the brushes and soaking up the excess with a rag, you may have to manipulate the fibers back into shape. To ensure that the fibers do not lose their shape, you should keep the brushes in a cup or jar with the fibers pointing up. When traveling with your brushes, fasten them together with a rubber band and carry them in such a way so as not to deform the fibers.

1

To Clean the Brushes with Soap, Do the Following:

1. Lightly rub the brush on a bar of soap.

2. Softly rub the hairs on the palm of your hand until the soap penetrates between the individual hairs and lathers up. The brush will be perfectly clean when the soap suds are white. If they are not, repeat the operation as many times as necessary.

3. Wash the brush out well under a water faucet.

4. To get rid of the excess water, you can squeeze the brush hairs between your fingers, use a rag, or shake the brush. By lightly squeezing and turning the brush hairs between your fingers, you can return the hairs to their original shape.

4

Brushstrokes

On these pages we show you the strokes that the four recommended brushes leave in order to introduce you to painting in watercolor. We also offer some examples of brushstrokes with a round brush, so you can see for yourself how versatile this type of brush is.

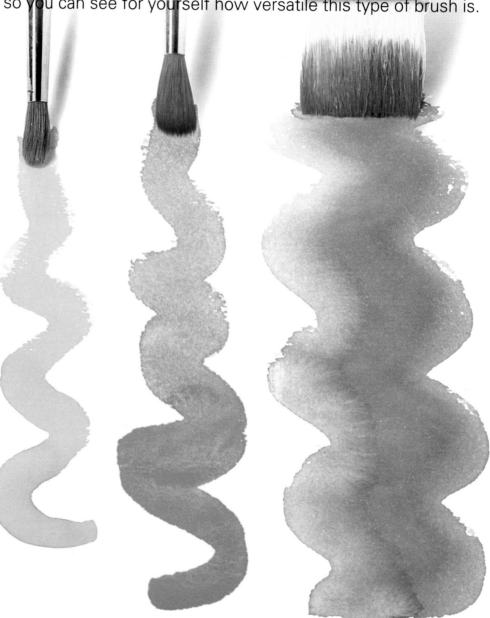

A number 2 sable hair brush

A number 4 ox hair brush.

A number 8 ox hair brush

A wide Japanese hog's bristle brush

Brushstrokes with Round Brushes

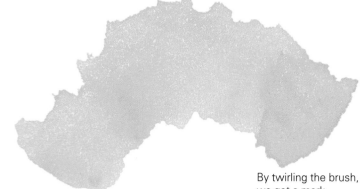

These brushstrokes have been made with a number 10 sable hair brush. Notice the versatility of the round brush and how well this type of hair paints. The round brush allows the user to make fine strokes by barely grazing the paper, and thick lines by applying more pressure.

By twirling the brush, we get a mark like this.

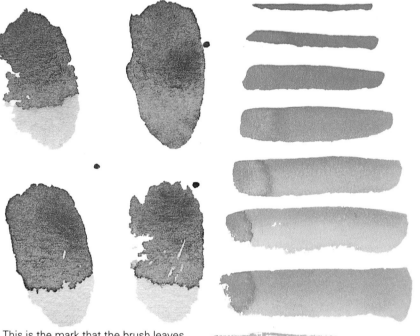

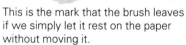

This is the mark that the brush leaves if we simply let it rest on the paper without moving it.

If we twirl the brush in a circle on the paper, like this, we can see the breadth of the brush's capacity.

By barely grazing the paper, we can make a fine line. If we add more pressure, we can make thicker lines.

You can make a long brushstroke without needing to return for more paint.

Stretching the Paper

Stretching paper with gummed paper tape is not very difficult, although it can be messy. Because it takes some time to do, it has lost popularity with artists who prefer to work with heavy paper and tack it to a drawing board. If you are a beginner, we suggest that you not hurry, and take the time to stretch your paper. This way you will avoid problems when you start to paint.

1. Before wetting the paper, have everything that you will need at hand: the board, the paper, the tape cut to size, and the sponge.

2. To wet the paper, first lay it on the board. Make sure that the side that you are about to wet is the one with the rough surface on which you want to paint. Next, soak the sponge in water and squeeze it out over the paper. This will form a small pool of water.

3. Spread the water softly over the surface of the paper with the sponge without pressing too hard to avoid spoiling the treated surface.

4. Using your fingertips, make sure that the entire surface is uniformly wet, and that there are no dry spots. When you slide your hand over the surface you will notice that the wet areas are slippery, while any dry spots you may have missed are rough.

1

2

3

4

Wetting the Paper

Paper expands when it is wet and contracts when it dries. Unfortunately, when the wetting and drying process is over, the paper does not remain flat and smooth. Instead, it warps. Small sheets of paper usually retain their original shape, but, generally speaking, paper with a weight of less than 140 lbs. wrinkles and warps when wet with paint.

The way to avoid this problem, which otherwise obstructs and slows down your work, is to stretch the paper. You must wet the paper before you stretch it, so that its fibers expand and increase in size. (There are certain types of paper that increase in size when wet by almost $4/_{10}$ ".) When dried, the paper will return to its original dimensions. It is not necessary to soak the paper: it is enough merely to wet it sufficiently so that the fibers expand.

Attaching the Paper

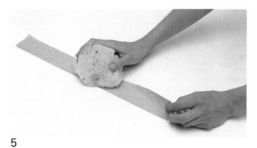

Before attaching the paper to the board with gummed paper tape you should lay the paper out flat on the board and wait five minutes, so that the paper fibers completely soak up the water, and the paper expands sufficiently. The only tape that sticks to wet surfaces is the kind that has glue on one side. To be effective, this tape must also be wet. Because of this added complication we recommend that you cut your four strips of tape and have them ready to use before you start the wetting process.

5

5. Wetting the tape with a sponge is the easiest way to do it.

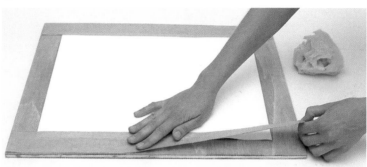

Drying the Paper

6

The paper must be left to dry in a flat position. Depending on how wet the paper is, the drying process will take between four and ten hours. Because of this, we recommend that you have various boards and stretch several sheets of paper at a time. This way you will always have paper ready to paint. One way of accelerating the drying process is to use a hair dryer.

Removing the Tape

When you have finished the stretching process and the paper is completely dry, you will notice that the paper remains perfectly stretched and flat for painting. This is the time to take the tape off.

The gummed paper tape functions as a margin, so cutting it off the board will leave the paper perfectly framed. To remove the tape you will have to wet it, taking care not to damage the painting. If you try to pull the tape off without wetting it first, it will tear the paper.

6. To ensure that the paper is uniformly stretched in all directions is to first tape one side, and then its opposite side; followed by a third side and its opposite.

Other Stretching Systems

If you are going to paint using paper heavier than 140 pounds without pre-wetting it, you can stretch the paper using clips, tacks, staples or masking tape.

REMEMBER . . .

■ Watercolor paper that is not stretched before it is wet with paint will warp when it dries.

■ You must never wet watercolor paper with hot water, since this could destroy the treated surface of the paper.

■ When wetting paper with a sponge, you should not apply any pressure because this can also destroy the paper's treated surface.

■ If you expose the gummed paper tape to the sun while stuck to paper, it will be more difficult to remove later.

Unsticking the Tape
The tape can be cut with a knife if you do not mind the remaining border around the paper. To remove this border you will first have to wet the tape, taking care not to damage the painting.

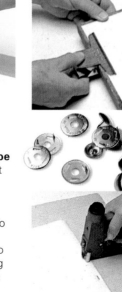

The Drawing

A preliminary drawing is the foundation of a painting, the pillar that supports the depicted work. The drawing takes on added importance when painting in watercolor, since this particular art form does not let you correct mistakes easily. Your work should therefore be planned before you start to paint.

The Importance of a Preliminary Drawing

When painting in watercolor, a sketch or detailed drawing of your painting is fundamental to the ultimate success of your finished work.

Watercolor painting needs to be thought out beforehand because it is difficult to correct mistakes once you have started. As a result, you need to know exactly what you are going to do, and then carefully study the model before you put brush to paper. A preliminary drawing is an essential part of this preparation.

If you are going to paint a landscape, you will need to make some preliminary sketches to focus on your theme and tonal values. This is important because the lighting and other features of your landscape will naturally change over time. Clouds, for example, will move while you paint them. That is why you should include in your drawings the shadows and placements of the figures that you intend to paint.

To draw on watercolor paper, it is best to use a soft pencil, such as number 2, HB, or B.

Copying an Image

If you do not yet feel comfortable painting a theme from nature, you can practice by copying a photograph. If you do this, a grid is helpful to assist you in the drawing and distribution of the figures within the paper's space.

Choose a photograph of the subject you want to paint. You can either copy the entire image, or perhaps choose just a part and offer a new perspective of the original.

1. Once you have decided on your picture, lightly trace a grid over the image, either with a ruler, a right triangle, or a 30/60 triangle. Then, make a similar grid on the watercolor paper. Most likely, the watercolor paper will be larger than the photograph, so naturally the grid will be on a larger scale.

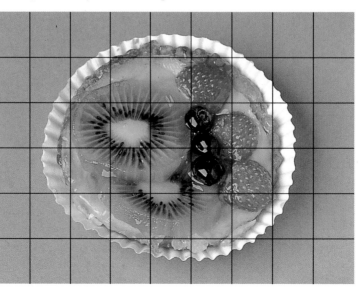

1

To trace the lines of the grid, you can either use a ruler, or make use of a right triangle.

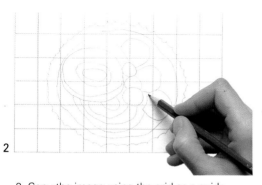

2

2. Copy the image using the grid as a guide, drawing lightly on the paper. Otherwise, you may score the paper's surface, or even tear through the paper. Bearing down on the paper also would make it difficult to erase later on. Avoid shading in the dark parts, since they will show through the paint if you do not erase them beforehand, and the applied watercolor will lose its brightness.

3. To erase the grid, use a soft eraser or an art gum eraser. Take this opportunity to soften the intensity of the drawing by lightly erasing the darker lines.

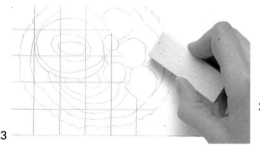

3

Erasing Before Painting

When sketching, take notes or study the model as you draw. You will have to remember where to place the shadows so that you can later assess the tonal values you intend to use; otherwise, you will lose details. However, when the time comes to draw on the watercolor paper itself, things change. You must always keep in mind that watercolor is transparent, and so, whatever pencil line you make will be visible after painting. In addition, the pencil's graphite will darken the watercolor tone.

Because of this, only sketch the most basic lines of the composition.

REMEMBER

■ The purpose of drawing on watercolor paper is to distribute the figures within the space without including too much detail that would detract from the spontaneity of the work.

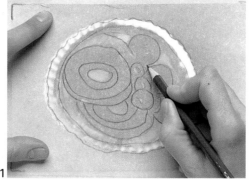

1

Tracing the Image

If you do not want to destroy the photograph, or do not want to waste time making a grid, you can use tracing paper.

Tracing paper and rice paper are two types of semi-transparent paper that let you trace any image comfortably.

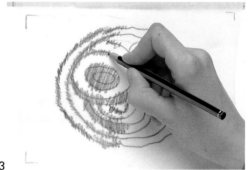

3

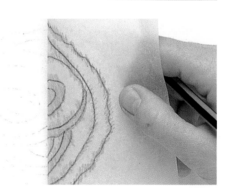

4

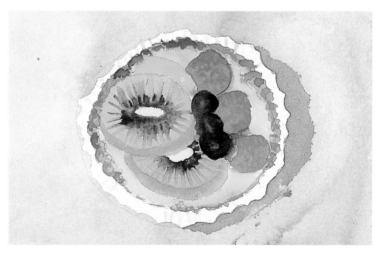

Transferring the Traced Image to the Watercolor Paper

1. Trace the basic outlines of the image, avoiding any detail.

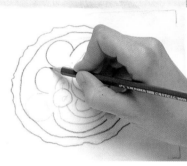

2

2. Turn the rice paper over and retrace the drawn image on the back.

3. Place this back side of the tracing, which is the mirror image of what you want to sketch, onto the watercolor paper, and rub the pencil over the lines.

4. The graphite from the back side of the rice paper will be transferred to the watercolor paper, leaving a light, but perfectly delineated copy of your tracing.

Wet Watercolor and Dry Watercolor

Although watercolor painting is by its very nature a wet process, there is a difference between what is called *dry watercolor* and *wet watercolor,* insofar as the end results of each techniques are quite distinct. Dry watercolor is painted on dry paper. Wet watercolor is painted while the paper is wet.

Dry Watercolor

Classic watercolor painting refers to dry watercolor, which consists of painting on dry paper.

The characteristics of the dry watercolor technique are its precise and well-defined brushstrokes. The paint where one color ends and another begins is immediately discernible.

When you paint using the dry watercolor technique, the paint stays where it is applied, perfectly delineating the limits of the stroke. The result is much more controllable than painting on wet paper. On dry paper, on the other hand, there is the ever-present risk that you will make undesired breaks in your work.

When a brushstroke is made on dry paper, the paint stays where it is applied and the outlines of the stroke remain well-defined.

Notice how the tone here changes, producing a break.

WHAT IS A BREAK?

When we paint over an area of a painting that is already painted with the same color, or even a different color, the base color changes in tone. This is how glazes are obtained.

When this change in tone is sharp and unwanted, it is called a *break.* That is to say, a break is an abrupt change in the continuity of a color.

Generally speaking, breaks constitute a problem, since the tone variations in a given area of a painting may suggest unwanted shapes, or indicate an error by the artist.

The artist can intentionally create breaks in his or her work. Sometimes, breaks are helpful to increase the intensity of a color as required by the theme, lend volume to a form, or suggest a shadow or the irregularity of a surface.

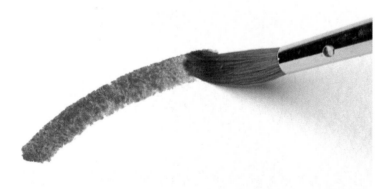

Wet Watercolor

Wet watercolor is the technique whereby paint is applied on wet paper.

Painting on a background that is not yet dry, or that has been wet especially for the purpose, creates an effect that is dramatically different from the effect created by dry watercolor.

This technique is wonderful for painting skies. Clouds take on a full but ethereal quality that cannot be replicated using the dry watercolor technique.

On wet paper, the paint expands in an uncontrollable way.

When painting on wet paper, the brush slides easily and the pigment expands in all directions moments after you raise the brush from the paper. The contours of the stroke are imprecise and vague, the colors blur and run together, and the work takes on a misty, vaporous air.

Do not forget that the manner in which the pigment expands is unforseeable and is a function of the degree to which the paper is wet. The wetter the paper, the more the pigments bleed and expand.

REMEMBER . . .

■ If you do not know how watercolor paint reacts on wet paper, the results will surprise you.

■ The greater the degree of a paper's wetness, the more the pigment expands over it.

■ You can use both the wet and dry techniques on the same work.

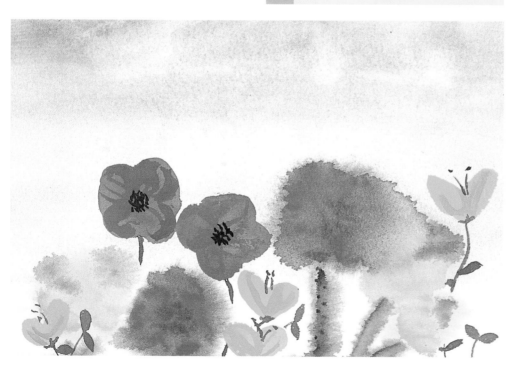

These flowers have been painted on both wet and dry paper. Notice how those painted on wet paper have blurred edges. The pigment has expanded freely and uncontrollably. The flowers that were painted on dry paper have perfectly delineated borders, and the application of the paint is controlled by the artist.

One Color

Before facing the challenge of color in watercolor painting, you may want to familiarize yourself with some basic ideas regarding tonal values. To do this, it is essential that you start with only one color.

The Wash

A *wash* is a term that refers to the application of very diluted paint on paper. (Remember that this term also refers to the solution of water and paint that is prepared in a paint well.)

WHAT IS A FLAT WASH?

A flat wash is one that keeps the same tonal value throughout. The result is a film of color that neither varies in tonal value nor brushstroke. Washes are used to give a tinge of color to white paper, to create backgrounds, and to paint skies.

HOW TO PAINT A WASH

It is always worth-while to test your colors first on a separate piece of paper.

Applying a wash involves covering a large area with paint diluted in water. The color of the wash must be light enough to let the white paper show through. This will allow you to use light tonal values later on in the work.

Remember that with watercolor painting you cannot superimpose a light color over a dark one, and that watercolor paint loses it luminosity when it dries. Because of this, we suggest that you first make some color tests on a separate piece of paper.

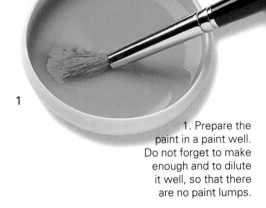

1

1. Prepare the paint in a paint well. Do not forget to make enough and to dilute it well, so that there are no paint lumps.

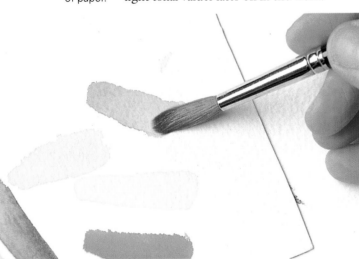

REMEMBER . . .

■ The wash should be done in light tones. These tones will allow for the creation of the entire gamut of colors particular to the work.

■ An absorbent brush should always be used to do the wash.

■ It is important to prepare enough paint for the entire wash in order to avoid running out of paint or risk having to complete the wash with a newly prepared, different tone.

■ If a wash takes longer than it should to dry, time how long the drying takes, and make note of the time you started painting over it.

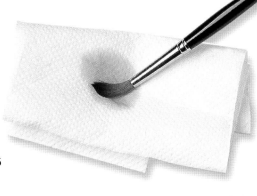

2

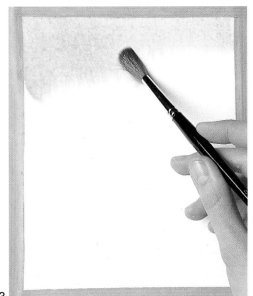

3

4

5

6

2. Lightly moisten the paper so that you won't get breaks while painting.

3. Load the brush with enough paint, and begin by painting a horizontal strip at the top of the paper. Note that the inclination of the board will make the liquid accumulate at the bottom of the strip, thus allowing you to obtain a uniformly painted zone. With the following pass of the brush, join the two strips without any breaks.

4. Continue applying the wash, strip by strip.

5. When you come to the bottom edge, squeeze out the excess paint in a rag or paper towel.

6. With the brush rid of most of the paint, run it over the bottom edge of the paper to remove the paint accumulated there.

LIFTING A WASH

If you are not happy with the intensity of the color, or if, upon drying, the wash is too dark, there is always the possibility of saving the paper by washing it under a faucet or with a sponge. Bear in mind, however, that certain pigments retain their color more than others, and that it is always difficult to bring the paper back to its original white.

When washing the paper under a faucet, it might help to use a sponge.

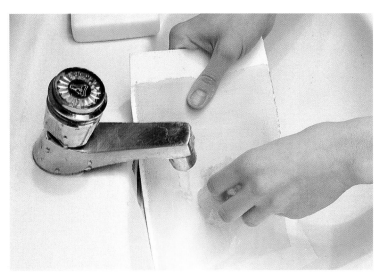

The gradation of values of this flower has been achieved by superimposing glazes.

Values

WHAT ARE THEY?

A value is the degree of intensity of any given color on a scale ranging from light to dark. That is to say, each color comprises an entire range of values, from the least to the most intense. This variation in intensity allows you, for example, to construct a monochromatic work in which values give rise to the form, according to their degree of lightness or darkness.

HOW TO VARY THE VALUES

There are two basic ways of creating a range of values or tones of a specific color.

Diluting the Paint

With watercolor paint, the value of a color is lightened simply with water. The greater the amount of water, the lighter the value or, to put it another way, the intensity of value decreases.

In this way, the entire value scale is created, from the darkest to the lightest. The most intense value will have the largest proportion of pigment. In this case, the paint is dissolved just enough to apply it to paper. The lightest tone is obtained by diluting the paint with more water.

This value scale was produced by diluting the paint each successive time a new form was painted.

Superimposing Glazes

A glaze is the application of a coat of transparent color on paper. The application of one glaze over another of the same color increases the intensity of the tone.

By diluting the paint, tonal values from the highest to the lowest intensity are created; by superimposing glazes, the reverse occurs. You start with a light value, which darkens with each coat of glaze.

Monochromatic Washes

It is possible to paint a watercolor using only one color. This is done with wash, an excellent means for understanding how a watercolor painting is created, and for appreciating the importance of value in a picture. Please remember that the term "wash" also refers to a solution of water and paint in a paint well; to avoid confusion, keep in mind that there are two distinct definitions.

WHAT ARE WASHES?

A wash is a painting on paper using very diluted watercolors.

Generally, a wash is monochromatic or, at most, uses only two colors. In other words, a wash is a watercolor painting made with the white of the paper and a specific color's range of values.

To paint in watercolor, it is essential to understand what the lack of white means. Understanding this is the only way to understand the great importance of assessing the tonal value of a model before embarking on a painting using all colors. Practicing painting with wash will be a great help in acquiring a good watercolor technique. To be a monochromatic painter you must make the values do the work that normally is performed by colors. You will have to turn the colors of your model into values in order to construct its form.

PAINTING A WASH

A wash is a monochromatic watercolor. As such, it must be created according to the classic precepts of starting with the lightest tonal values and finishing with the darkest.

When painting a wash, it is highly recommended that a dark color be included in order to lend more contrast to the painting, and allow for the whole gamut of tonal values.

Examine the following images and you will understand how a wash is developed, step by step.

This wash painting of a beach scene was done using ivory black and a number 8 sable hair brush.

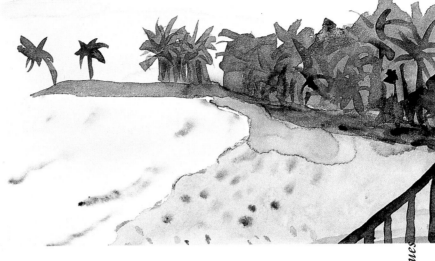

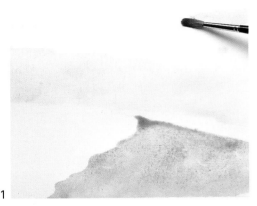

1

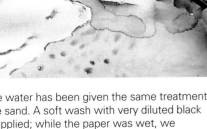

3

1. We begin by applying the lightest values, in the areas of the beach and the clouds in the sky.

2. Taking advantage the paper's dampness, we add some small touches with the point of the brush to suggest tracks in the sand and the remains of seaweed.

2

3. The water has been given the same treatment as the sand. A soft wash with very diluted black was applied; while the paper was wet, we suggested some soft waves. Afterwards, we begin to develop some of the vegetation with a darker value. Notice how the paint has expanded unexpectedly, creating a damp stain in the sand.

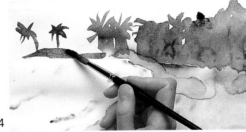

4

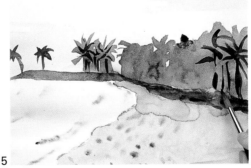

5

REMEMBER . . .

■ A poor value study of your model, or a failure to study the shades and hues before beginning, may make you paint a zone too darkly. As a consequence, you will be forced to darken the rest of the painting to maintain the general tonal relationship. On the other hand, if, by attempting to avoid this problem, you hesitate to run any risks whatsoever, you will end up working only in intermediate tones. Do not be overly cautious, because the result will be a flat, boring, and inexpressive work that won't be of much interest.

4. The land between the trees and the sand is indicated with a value slightly darker than the vegetation.

5. While the background is still slightly damp, we paint with small brushstrokes the suggestion of palm trees. This slight degree of dampness will let the paint expand minimally, to create a feeling of atmosphere.

6

6. To finish up, we paint a railing in the foreground with the darkest tone onto dry paper. This form, which stays sharp and clear, lends a sense of space and depth to the rest of the painting.

Two Colors

Having accustomed yourself to painting in one color, we suggest you venture forth and begin to learn how to mix paints. The easiest way to do this is to begin with just two colors, so that you can start to appreciate how they react with each other.

Variegated Washes

Variegated washes are those that include more than one color on paper. These washes can be quite beautiful for making backgrounds, creating special effects, and suggesting textures.

Orange painted over a blue background.

An intense burnt sienna and this lighter value of green could be the background for a landscape.

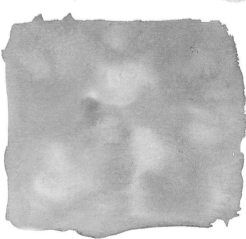

Some circular brush-strokes with a sepia colored paint over an ocher background that was still wet.

Staining the paper with various greens creates this curious effect.

Grading Washes in Two Colors

A graded wash is one in which the color and value gradually lose intensity as you paint. Graded washes are quite useful to suggest a sky whose blue color loses intensity as it approaches the horizon.

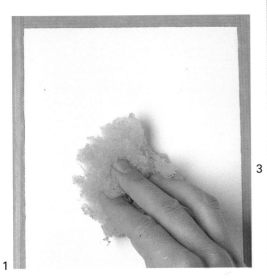

1

2

3

4

Grading Washes in Two Colors

1. Wet the paper so the two colors will run softly together.

2. Paint one part of the paper with the lightest tone without reloading your brush with paint, so that the value loses intensity as you move down the page in horizontal bands.

3. Turn your board upside down and paint the other color in the same manner, so that the two colors mix without any abrupt changes in value.

4. While grading the color, if you notice that your brush has lost its paint, dip it in clean water instead of in paint. This will help to dilute the tonal value even more.

Over a medium yellow, we have painted some glazes of emerald green to create a more acidic green (a), a cobalt blue to get another green (b), a burnt sienna to make an orange tone (c), a black to make a brown (d), and an orange to create a lighter orange (e).

Mixing Colors by Superimposing Glazes

As we have learned, we can intensify the value of a color by applying a glaze of the same color on top. Using the same technique, we can also create a third color by superimposing a glaze of a color different from the background.

This method of mixing colors is often used in watercolor painting, but there are some hidden risks involved if you are unfamiliar with the technique. To begin with, it is essential that the background color be dry before the glaze is applied. If the background is still wet, the two coats will run together on the paper, as they would on the palette.

In addition, you need to be very familiar with your colors in order to have some idea of what your results will look like before you superimpose one glaze over another.

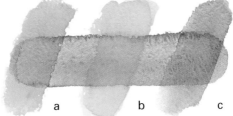

a b c

Over alizarin crimson, we have painted some glazes of permanent green to make brown (a), a yellow to create orange (b), and a blue to get purple (c).

a b c d e

REMEMBER . . .

■ In order to grade a wash of two colors properly, they must be made to merge together gradually.

■ The wonder of watercolor resides in the freshness that the transparency of the colors confers. Too many coats of paint, creating mixtures with glazes, can rob a painting of its spontaneity.

Three Colors

It is impossible to have all the colors of nature on our palette. Watercolor artists must by necessity mix colors to obtain the tones, or even a specific color, they want. The three primary colors allow you to produce an infinite range of colors, by mixing them together.

All Colors Are Three Colors

Cerulean blue, alizarin crimson, and medium cadmium yellow are the three basic watercolors most similar to the three primary colors. Theoretically, all the colors of nature can be obtained from these three colors.

Cerulean blue is the watercolor most akin to the primary blue cyan.

The watercolor alizarin crimson can be substituted for permanent magenta.

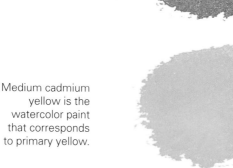

Medium cadmium yellow is the watercolor paint that corresponds to primary yellow.

Mixing Primary Colors

There is not a watercolor painter in the world who would put only the three primary colors on his palette with the intention of creating from them all the other colors he might possibly want to use. This would complicate his work to the point of absurdity, given the range of colors available on the market. Nevertheless, when you begin to paint watercolors seriously, you will soon realize that mixing colors is a routine task in the life of painters. So, it is important to begin to understand how colors react with each other, and to appreciate the possibilities that mixtures offer. To familiarize yourself with color mixes, it is helpful to perform some exercises with the three primary colors.

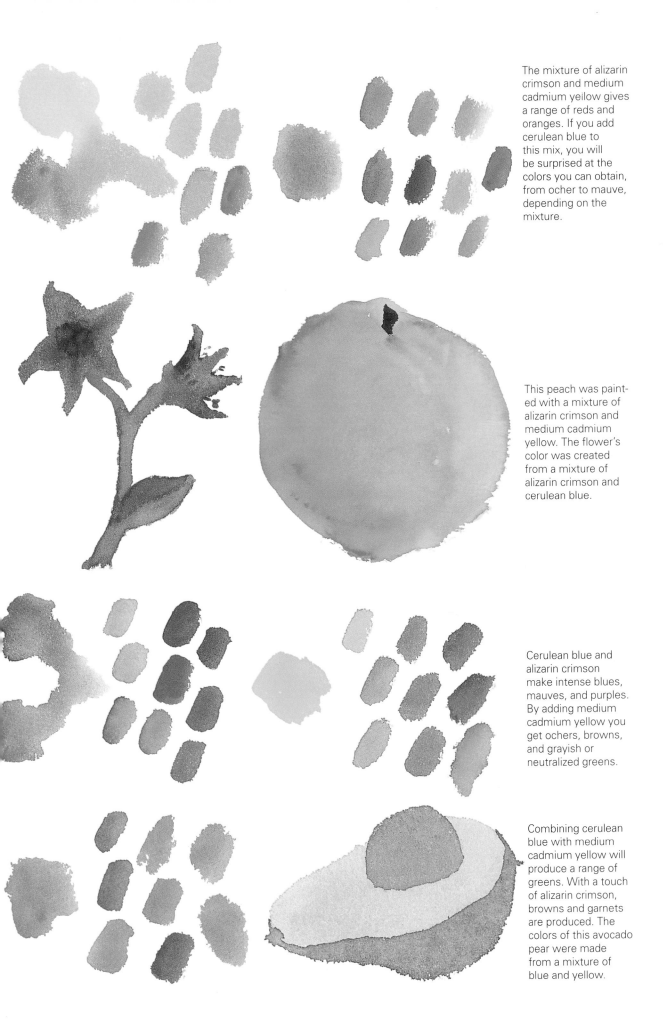

The mixture of alizarin crimson and medium cadmium yellow gives a range of reds and oranges. If you add cerulean blue to this mix, you will be surprised at the colors you can obtain, from ocher to mauve, depending on the mixture.

This peach was painted with a mixture of alizarin crimson and medium cadmium yellow. The flower's color was created from a mixture of alizarin crimson and cerulean blue.

Cerulean blue and alizarin crimson make intense blues, mauves, and purples. By adding medium cadmium yellow you get ochers, browns, and grayish or neutralized greens.

Combining cerulean blue with medium cadmium yellow will produce a range of greens. With a touch of alizarin crimson, browns and garnets are produced. The colors of this avocado pear were made from a mixture of blue and yellow.

Various Colors

After studying values, and familiarizing yourself with watercolor techniques by way of the exercises involving washes, you can now begin to work with all colors. At this point it is important to choose a palette that will let you make as many mixtures as you want for the subjects you want to paint.

Which Colors to Choose

When first considering the matter of which colors to choose, you should count on having a small palette with a few, well-chosen colors. Bear in mind that if you use too many colors, it will take a long time to get to know them and how they react with other colors, and you will get lost trying to come up with the exact brown or precise tone of green.

Because of this, we recommend a box of fifteen colors, which will allow you to obtain all other colors through the use of mixtures.

Mixing colors is unavoidable when working with watercolors, because no set of colors incorporates all the colors of nature. Besides, mixing colors allows you to get to know the basic colors more intimately, and forces you to develop your own chromatic style, which will lend personality to your work.

We suggest here fifteen basic colors that will let you get on with whatever theme you choose.

*Lemon yellow

Cadmium yellow

*Cadmium orange

Cadmium red

Alizarin crimson

Sepia

Permanent green

Emerald green

*Olive green

Cerulean blue

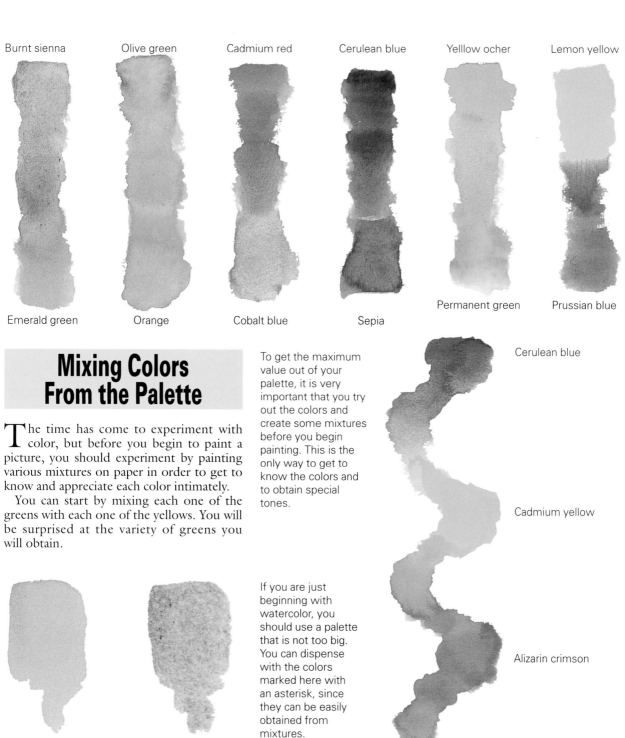

Burnt sienna · Emerald green

Olive green · Orange

Cadmium red · Cobalt blue

Cerulean blue · Sepia

Yelllow ocher · Permanent green

Lemon yellow · Prussian blue

Mixing Colors From the Palette

The time has come to experiment with color, but before you begin to paint a picture, you should experiment by painting various mixtures on paper in order to get to know and appreciate each color intimately.

You can start by mixing each one of the greens with each one of the yellows. You will be surprised at the variety of greens you will obtain.

To get the maximum value out of your palette, it is very important that you try out the colors and create some mixtures before you begin painting. This is the only way to get to know the colors and to obtain special tones.

If you are just beginning with watercolor, you should use a palette that is not too big. You can dispense with the colors marked here with an asterisk, since they can be easily obtained from mixtures.

Cerulean blue

Cadmium yellow

Alizarin crimson

Permanent green

Orange

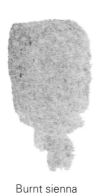

*Yellow ocher

Burnt sienna

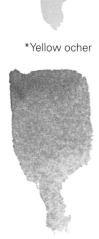

Cobalt blue

*Prussian blue

Ivory black

White Areas and Highlights

A large part of a good watercolorist's talent is based on the ability to plan the work and use the white of the paper as a color. The white of the paper can be used to suggest highlights and reflections of light. Two basic methods exist to take advantage of the paper's color: leaving an area of the paper unpainted, or preserving white, and removing paint after it has been applied.

Preserving White

What is understood in watercolor painting as preserving white on an area of paper is leaving it unpainted, in order to use the white of the paper as a color. Preserving white implies deciding beforehand which parts of the work will retain the color of paper to recreate a reflection or suggest the white wall of a house. Leaving paper unpainted is the cleanest and purest method by which the color white can be obtained, and can be carried out in several ways.

To preserve white areas, you only have to avoid touching the area in question with the brush. In other words, you must leave that area unpainted to maintain the whiteness of the paper.

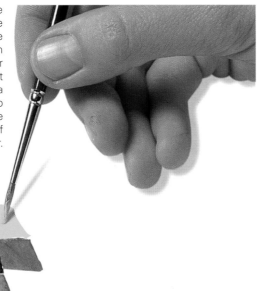

PAINTING

A large part of a watercolor painter's talent consists of the ability to plan out the work prior to painting, and the ability to paint by preserving white spaces. In other words, the talented artist successfully avoids touching the area left white with the brush, but shapes it by painting the surrounding areas.

The artists that master this technique use it habitually. You can do it, too. It is only a matter of practice. What is clear is that this method for preserving white areas is easier when the areas are simple shapes with well-delineated outlines, such as, for example, a table top or a wall. If you find that you need to leave a complicated area white, there are other methods available that might be more appropriate to make your task easier and your apprenticeship less painful.

REMEMBER . . .

■ To preserve white areas in a painting you must plan the work beforehand, and know exactly where the zones are that you do not want to paint.

■ You must never let masking fluid dry on the brush, because the brush will be ruined. Use an old brush, and wash it with soap after use.

■ Once you have preserved a spot with wax, you cannot remove it from the paper, so you must know exactly what you intend to do before you begin to apply it.

MASKING FLUID

Masking fluid is a substance that is applied on paper in a moist state, and is taken off easily once it is dry. It is impermeable, so it isolates the areas of the paper that have been treated with it from wet paint, thereby preventing the paint from coloring the paper.

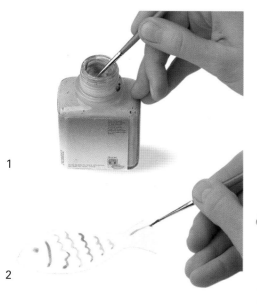

1

2

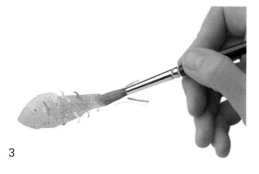

3

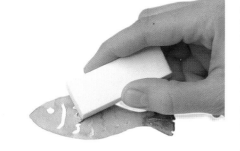

4

5

WAXES

Wax is an impermeable substance that repels water. This also makes it a good medium to preserve white areas in a watercolor.

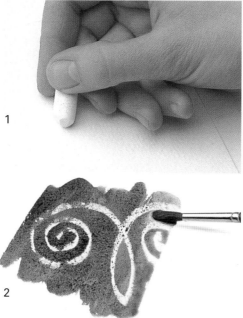

1

2

Lifting Methods for Removing Paint

To lift white areas means to recoup the color of the paper after it has already been painted over. There is a difference between preserving white areas with masking fluid, which maintains the purity of the paper's color, and this method, which leaves the paper slightly discolored after lifting the color. Although it may seem impossible, if you use a medium quality paper and work correctly, you will be able to lift out white areas that are almost as clean as the paper itself.

Nonetheless, in many cases it will not be exactly like the original white, so the touches of light and reflected glints made by this technique are of help only if you like a softer and more subtle result than that obtained by preserving white.

Besides using it as a method for correcting a mistake or salvaging a flooded area, this technique of lifting out white areas is used to grade color, create shades, and retouch skies.

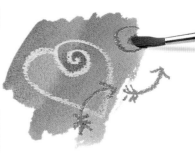

To preserve white areas like this you can use colored wax pencils.

Preserving White with Wax

1. Apply wax to the area to be left white.

2. Paint normally without pressing down too hard on the brush over the wax, because too much pressure might force the pigment through, and into, the paper. You will see when painting how the wax repels the watercolor paint and the reserved parts stay white.

Preserving White with Masking Fluids

1. Put a small amount of masking fluid on an old brush. Don't risk using a new brush, because masking fluid easily destroys the bristles.

2. Apply the masking fluid to the paper as if it were paint.

3. When the masking fluid is dry, paint with watercolors in the usual fashion.

4. To remove the masking fluid, you can use a soft eraser, or even your own finger.

5. Here we can see how the preserved areas have remained free of paint.

Lifting Out White on Wet Watercolor

B asically, lifting out white in this case means absorbing paint from the paper before it has dried. This practice is closely tied to the act of painting: learning this method is useful to lighten color and to correct mistakes in general. You should practice this technique until you feel at ease with it before actually painting a work.

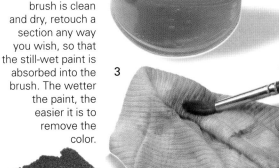

1

WITH A DAMP BRUSH

You can remove paint with a clean brush drained of paint just as you paint with a brush loaded with paint.

With a Dry Brush

1. Paint on the paper as usual.

2. Clean the brush in water.

3. Use a rag to soak up the water in the hairs.

4. Now that the brush is clean and dry, retouch a section any way you wish, so that the still-wet paint is absorbed into the brush. The wetter the paint, the easier it is to remove the color.

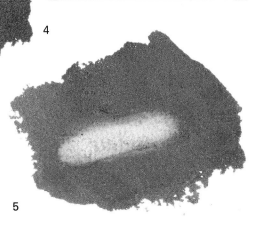

2

3

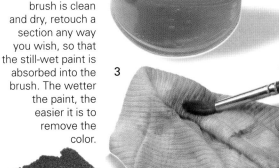

5. If you want to soak up more color, wash the brush again and repeat the operation as many times as you wish. In this way, you can achieve a fairly clean white.

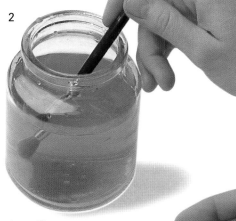

4

5

WITH A TISSUE

The results of using a tissue depend in large part on how you have folded the tissue before you start soaking up the paint, and how much pressure you apply to the paper. In any case, you should use white tissues.

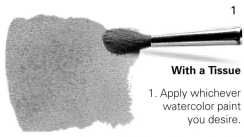

1

With a Tissue

1. Apply whichever watercolor paint you desire.

2. Absorb the wet paint with a tissue.

3. Notice the different forms you can get with the tissue.

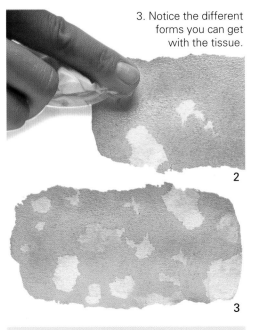

2

3

LINES

A fingernail, the end of the brush, a tooth-pick, a comb, or any other object with a point can be used to make white lines by dragging the object over the paper while it is still wet.

Notice that some lines have actually darkened the tonal value. This happened because the lines were made when the paint was still too wet.

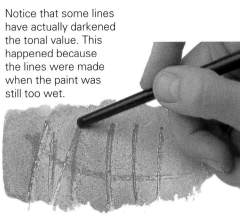

Lifting Out White on Dry Paint

Even when the paint has dried, you can equally well lift out a white area. There are two different methods for doing this: you can either scrape the paper or you can wet the paint again.

SCRAPING

This method inevitably implies damaging the surface of the paper, even if it is just a little. Nonetheless, if the paint is dry, this may not be a bad way to create certain effects. You can paint over the scraped zones again if you want to shade in the white areas.

With a Knife

Scrape the knife lightly to create the form you desire.

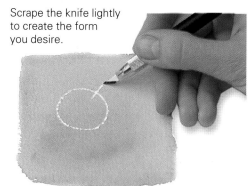

With Sandpaper

1. Rub sandpaper lightly over dried paint.

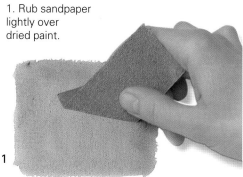

2. Here the texture of the paper surface is an important factor in the results. A rough texture paper always retains paint in the cavities. The paint can only be removed from the protruding bumps of the paper.

WETTING THE PAINT

Another way of lifting out white on dry paint consists of wetting the paint again with clean water to dissolve the pigment particles.

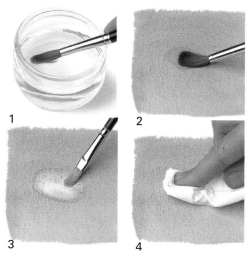

OTHER TECHNIQUES

To add some touches of light, or accents of white, you can always revert to gouache or Chinese white, which are opaque paints that can be superimposed on a base without losing their color.

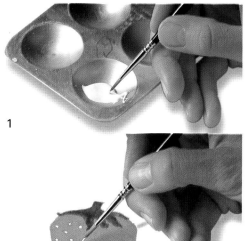

With a Brush and Tissue

1. Soak a brush in clean water.

2. Wet the area to be treated with the brush and wait a moment to let the paint dissolve.

3. Rub the brush softly to work the color loose. For rubbing, it is more effective to use a brush with hard bristles, such as hog bristle.

4. Absorb the color with a tissue or paper towel.

5. If you follow this procedure, you will get a clean white.

If you do not get the white you want the first time around, you can repeat the operation several times, taking care not to damage the paper. If you want a more intense white, you can make a solution of 50% bleach and 50% water, which will help remove the color. Bear in mind that bleach leaves a ring around the borders where it is used, and will not permit later gradations of color.

With Chinese White

1. Dip your brush in Chinese white.

2. Apply light and precise touches with the brush on the paper. You do not have to use very much Chinese white, because it is opaque and contrasts with the transparency of other watercolor paints.

Tricks of the Trade

With watercolor painting there are a series of techniques that are known as *tricks of the trade*. These techniques can offer some interesting alternatives when the time comes to solve certain problems, such as achieving a complicated edge, or creating a specific texture.

Water

It is recommended that one jar be used to wet the brush for painting and another for cleaning the brush afterwards.

Water is the basic ingredient for applying watercolor. The quality of water, its excess or scarcity, and the other substances that are added to it will determine the result of each brushstroke.

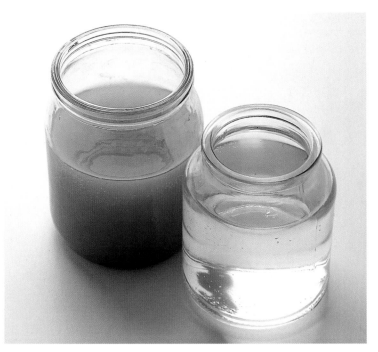

WATER RECEPTACLES

Let us begin with the number of receptacles that can be used for water when painting. What you are going to use is a personal matter that you will have to decide for yourself when you have a bit more practice and experience, and an understanding of the difference between using only one jar of water or several.

If you use the same jar for wetting the brush to soak up paint and for cleaning it afterwards, the subsequent colors will be slightly muddied and the entire work will take on a more neutral tone.

If you use two jars, one for taking water for paint and another for cleaning the brush afterwards, the colors will maintain their purity. In any event, if fresh color is what you are looking for, you should change the water from time to time.

You can work with several jars. One to clean the brushes, one for cool colors, and one for warm colors. You can even group together certain tones for specific jars, one for earth tones, one for blues, and so on.

For a beginner, however, this is a bit extreme, and will only slow down your first attempts. Watercolor painting is complicated enough as it is. It is best to use two receptacles, one for taking water into your brush and another for cleaning the brush afterwards. Change the water when it starts getting too cloudy.

A teaspoon of sugar dissolved in the water will extend the drying time.

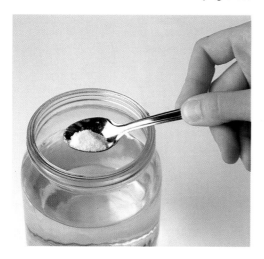

SUGAR

If you are painting in the sun or in a hot place, or if it is summertime, bear in mind that paint will dry more quickly. If you want to extend the drying period, so you can paint comfortably and without hurrying, just drop a teaspoon of sugar into the water you are using to paint with. Sugar retains water, and will help you avoid undesired breaks due to an inordinately rapid drying process. Sugar will also help avoid irregularities that can be produced in backgrounds, gradations, and other types of flat colors. Finally, you can resort to sugar to wet the paper before beginning to paint. In this case, put two lumps of sugar into a glass of water.

REMEMBER...

■ To preserve the purity of the colors, do not use the same jar for cleaning brushes that you use for dipping the brush in water to load the paint.

■ So that the entire work takes on a homogeneous tone, use the same jar for both taking water and cleaning the brush.

■ When you are lifting out paint with clean water the pigment mixes with the water, depending on how damp it is. You won't know the true result of your work until it has dried.

■ Each type of paper absorbs water in a different way. If you are testing a color or an effect, you should use a bit of paper of the same weight and texture as the paper you are painting on to avoid unpleasant surprises.

PAINTING WITH CLEAN WATER

When pigment comes into contact with water, it disperses and accumulates along the edges of the wet area. Because of this, in order to mix the pigment well on the palette, you must move the brush around in circles. This same capacity of water to make pigment expand can also serve when retouching work or to create certain effects.

By wetting a clean brush in clean water and working on wet paint, we can retouch areas of color, separating the paint within those zones, imitating textures, or otherwise creating special effects.

Each time you repeat the operation, you will have to clean the brush, since some paint will have soaked into it. The two values—the background value and the value you are creating with the water—will mix together. If the two areas mix together you won't achieve the contrast of values that you are looking for, and the result will appear more like a gradation.

1. Paint an area of color.

2. Load a clean brush with clean water.

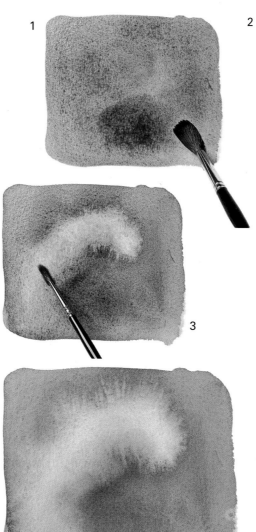

3. On the wet paint, slide the brush softly over the area, letting the paint disperse in the direction you want.

4. Watch how the particles of pigment accumulate along the edges of the wet spots, depositing more intense tonal values there that separate the value of the background from the lighter value you have made by retouching.

1. Once the form you want to outline is painted, you can proceed to trace a line around the color of the background. Paint it calmly but without stopping. It is important to keep in mind that the line being traced should not be allowed to dry.

2. Once the outline is finished, use a thick brush and fill in the area starting from the outline and working inward.

3. Now that the area nearest the border is painted, you can paint freely, without fear of going over the border.

Complicated Borders

One of the big problems a novice painter encounters involves borders between one color and another. If the paint is dry, it is easy to create breaks unintentionally. If the brush has soaked up too much paint, drips and pools will form on the paper. And when working wet on wet, paint expands in uncontrollable ways. Any one of these three factors can ruin a painting and put an end to your patience. You should not get depressed over these accidents. They are common to watercolor painting and happen often. Nonetheless, we will show you several methods to help you avoid these problems until you are more experienced.

First, never forget that painting on wet paper means that the pigment will inevitably expand. Because of this, we recommend that you wait until the paper is dry if you have to outline a difficult area. If you do not want to wait, there are other options.

OUTLINING WITH A FINE BRUSH

Generally speaking, a thick brush is used to cover large areas and a medium-sized brush is used to paint. Sometimes, we may begin to paint with a medium-sized brush to fill an area, but find that it is difficult to outline the borders without losing the freshness of the large brushstrokes. To maintain the freedom of a larger brush without crossing over onto parts already painted, you can put into practice a method that consists of painting the borders with a fine brush and later filling in with a thick brush.

The only inconvenience with this method is that you have to paint relatively quickly since, if the profiled line dries, breaks can form while filling in the area.

One way to avoid this is by lightly moistening the part to be painted, being very careful not to wet any part already painted. Otherwise, you run the risk that the paint will bleed into the area you want to paint.

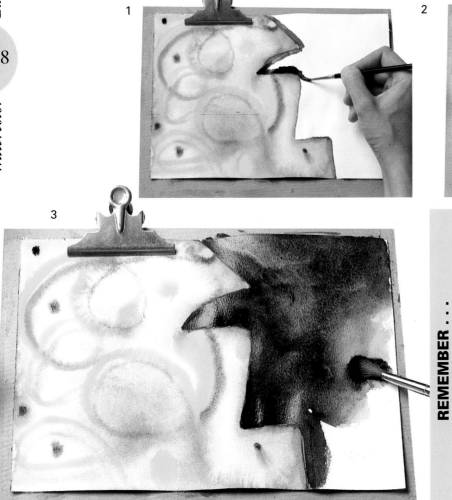

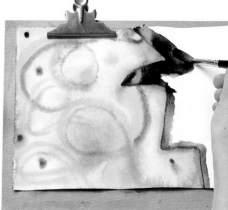

REMEMBER . . .

■ If you are going to profile a complicated outline, let it dry first, since painting wet on wet will make the outline run and bleed.

■ To ensure that the line of paint that outlines the form does not dry, you will need to lightly dampen the area to be filled in and paint rapidly.

■ If you turn the board upside down before the paper has absorbed the excess water, paint may dribble down into the unpainted section below.

■ When painting straight lines with a ruler and brush, never let the ruler rest completely on the paper, or you run the risk of smudging the paint when you take the ruler off.

TILTING THE BOARD

Another large obstacle facing the watercolor novice is the slope of the board. If the board is completely vertical, the paint will drip down the paper. If the board is flat, your view of the work will be distorted. An incline of 45 degrees is best for beginners. Although this angle of incline is not very large, it is steep enough to make it hard to stop rivulets of paint from dripping down the paper from a well-soaked brush. Because of this, many artists turn the board upside down when they have finished painting the lower half of the paper. It is a good way to avoid messing up the half of your work already painted. This method is helpful even if you have not started painting yet, and want to preserve intact the white of the paper. The procedure is quite simple.

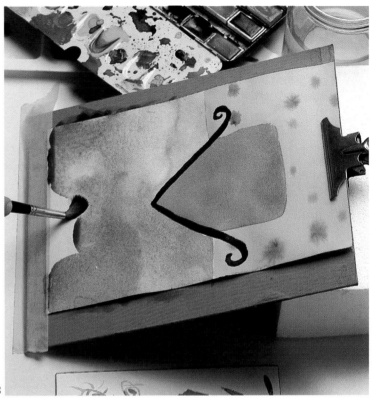

3

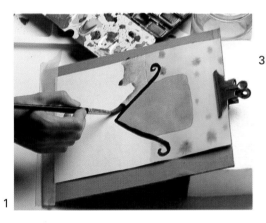

1

1. Once the lower half is painted and dry, turn the board upside down. Keep in mind that if you have painted with a lot of paint and you turn the board over immediately, drips from the painted half may run down the paper, staining the very part you intended to protect. Begin painting at the border of the painted half and work down.

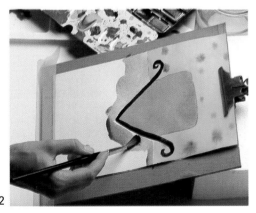

2

2. Drips and pools of paint may form, but this is not a problem, because there is nothing to stain.

STRAIGHT LINES

When you start to paint, you will probably discover that it is more difficult to trace a straight line with a brush than it is to draw a curve. The mast of a ship, the wall of a house, or the edge of a sidewalk can be a problem. The solution is quite simple. You can use a ruler or any straight edge, but do not use it as you would with a pencil.

To trace a line with a ruler and brush, you should never let the ruler lie completely flat on the paper. Rather, you should hold it at an angle so that the edge along which the brush will run does not touch the paper. If the ruler is flat on the paper, dragging the brush along it will force paint under the ruler. If this occurs, the paint will be dragged when you lift up the ruler, and instead of a line you will have created a series of paintblots.

Straight lines drawn with a ruler do not have the same naturalness as a line drawn freehand. To retrieve the freshness of a sponta-neous stroke, and cover the rigidity of the line, you can paint over it again by hand.

3. Notice that this technique produces a natural gradation in tonal value. The part above is a lighter value and the part below is more intense, due to the accumulation of pigment.

Effects

SALT CRYSTALS

The results of applying salt to wet paint vary according to the amount of salt and the wetness of the paint.

Grains of salt on wet paint produce an effect that can suggest textures like porous rock or rust on a fence.

Salt absorbs water, and the way the paint dries on the paper creates curious forms, rather like snowflakes.

The results of this method are a function of the quantity of salt sprinkled on the paper and the proximity of the grains to each other. The degree to which the paper is wet also plays an important role in the results. The wetter the paint, the larger the stains will be that each grain of salt produces.

SPATTERING

Spattering, or spraying, consists of applying thousands of tiny droplets of color onto the paper. Droplets can be easily produced by rubbing a toothbrush filled with paint against another object.

This technique is interesting to know about although the result is a bit off the normal watercolor path. Spattering is used to suggest textures like sand on a beach or foliage. It is also used as a way to liven up an area that seems a little flat and boring. A spray of darker colors can offer some needed contrast.

Before putting this method into practice, keep in mind that spattering can be difficult to control and will stain areas of the paper that you did not want to spray. Because of this, you should preserve

the areas that you do not intend to spray by using stencils or masking tape.

Once you have covered the areas that you do not want to spatter, fill your toothbrush with paint. You can do this by dipping the toothbrush directly in a paint well, or by using your brush to transfer the paint to the toothbrush. Keep in mind that if the paint you are using is too thick, it may stick to the toothbrush; if, on the other hand, the paint is too watery, the drops will be too big, and the results will look more like a paint splash.

To spray watercolor from a toothbrush, you will have to rub it against some object, such as a knife. If you are not worried about staining your hands, you can use your thumb. To direct the spray, pull the bristles in the direction opposite to where you want the spray to go.

SPLASHES

Splashes might be the most unpredictable method of all. Even though you may try to direct the brush toward the area where you want to splash, the paint droplets often disperse in unexpected directions.

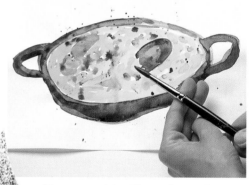

To create this effect, all you have to do is fill your brush with paint and knock it a few times against your other hand. The droplets then splash onto the paper.

Naturally, the density of the paint, the size of the brush, and the distance from which you shake the brush, all affect the results. The more watery the paint, the more drops are produced and the easier drops fly off the brush. A thick brush produces larger drops than a fine brush. If you move the brush farther away from the paper it is more difficult to control the direction of the drops.

1. Make a design with a stencil.

2. Rub the toothbrush bristles against something.

3. Examine the result.

1

2

3

Painting with . . .

ROLLERS

A small roller used in artistic painting is basically used to fill in large areas of color rapidly. Some artist use them to give a light cream tone to the paint before painting. A roller can also be experimented with, because its wide tracks can suggest other possibilities.

As with a round brush, the marks that are painted depend upon the pressure used and the amount of paint on the roller.

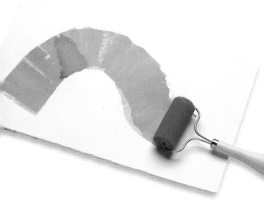

TOOTHPICKS

The irregular point toothpick impregnated with paint produces fragmented tracings that are ideal for suggesting rough surfaces like tree bark or fine branches.

The use of this method is quite simple. Just take a bit of color on the tip of the toothpick and drag it across the paper to leave a rough, thin line.

SPONGES

A sponge is another useful item in the watercolor painter's tool-kit, and its possibilities are limitless. It is used to soak up excess water from the brush, to absorb pools of paint that have collected on the paper, to create washes, and to create textures.

You can fill a sponge with paint by rubbing it directly on a paint cake, or first make a wash in a paint well and dip the sponge in that. When filling the sponge with color, you should wet the sponge, but not soak it, otherwise, when you place the sponge on the paper, you will likely squeeze out too much liquid and merely make an unseemly stain.

The same results will occur if you push down too hard on the sponge. To obtain the mottled effect of a sponge's surface on paper, you must use it gently.

The rough surface of a real sponge can suggest anything from foliage to pebbles. When painting with a sponge, you only need to dip it into the paint and apply it to the paper.

REMEMBER . . .

■ If you hold a brush too far away from the paper when making a splash, it will be more difficult to direct the drops toward the desired area of the paper.

■ To paint with a spattering technique, you will need to protect areas with stencils to limit the spray to your chosen area.

■ A sponge should not be soaked with paint, otherwise, when you begin to apply it to paper, it is likely that too much paint will smear the paper. As an obvious consequence, you will not create your desired texture, but merely a stain.

■ To obtain the mottled effect of the surface of a real sponge, you should dab the sponge lightly on the paper.

■ When scraping paper with a knife, do it lightly and try not to destroy the surface of the paper itself. The underlying tone of the scratched sections will show through in a few minutes.

KNIVES

A knife is yet another tool to use when painting. Do not load any paint on the knife before using it on the painting. Instead, superficially scratch the paper's surface. The area you want to scratch must be painted first. Scrape the knife across the paper's surface before the paint dries. The sharp point of the knife will scratch through the coat of paint. This allows the painter to penetrate to the darker color under the top layer, so the more intense color beneath will show through.

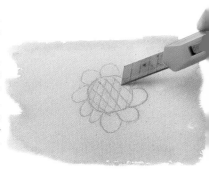

Light and Shadow

The play of light and shadow is what allows the artist to create the illusion of volume and depth. Just as there are distinct intensities and directions of light, there are also lighter and darker values in shadows.

Perception of Light and Shadow

All forms produce two types of shadow: their shadowed or dark side and the shadow they cast.

Everything the human eye sees is based on light. Because of light, we see the color and volume of figures. The color of objects depends on the type of light that illuminates them; their volume, in turn, is conditioned by the shadows that are generated.

Shadows are dark shapes cast by objects due to the light's effect. There is also the shadowed or dark side of a form, the result of less light striking that part of an object.

The direction and the intensity of shadows are conditioned by the direction and intensity of light. Shadows always follow the direction of light. A figure that receives light from the right will cast a shadow to the left. An object that is

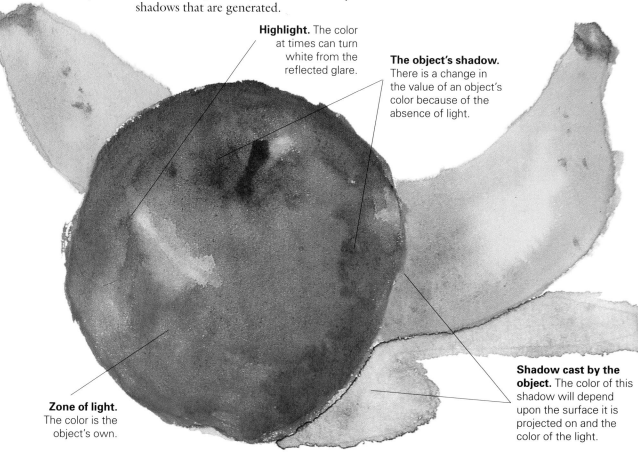

Highlight. The color at times can turn white from the reflected glare.

The object's shadow. There is a change in the value of an object's color because of the absence of light.

Zone of light. The color is the object's own.

Shadow cast by the object. The color of this shadow will depend upon the surface it is projected on and the color of the light.

softly illuminated will generate soft shadows. The same object under a strong beam of light will produce dark and perfectly delineated shadows.

Because of this interplay of light and shadow a painting can create the illusion of volume and three-dimensionality.

Every object produces two types of shadow: its own shadowy area where light does not strike directly, and the shadow that it casts upon other objects.

In addition, any object exposed to light presents a range of tonal values that extend from the lightest to the darkest.

Afternoon light bathes the objects with warm tones and, paradoxically, produces long shadows and cold tones.

The light of midday, on the other hand, produces hard, warm, and sharp shadows.

Atmosphere

Rendering atmosphere is something that might seem difficult to imagine when painting in watercolor because air is colorless. In practice, however, it is a relatively simple exercise.

What Is It?

In painting, *atmosphere* is the representation of air that is interposed between the spectator and what is being observed.

The influence of atmosphere on human perception is considerable. As a direct consequence of atmosphere, objects lose more and more sharpness the farther away they are from the spectator. Distance also makes objects lose color and contrast. The color of distant objects, therefore, generally, take on neutral, cool values.

Atmosphere is real. It affects our perception of objects, so artists must take it into account when they paint.

How Is It Painted?

There are three very important points to keep in mind when painting atmosphere:

1. The foreground plane of a work must be made of sharp contrasts, to give the sensation of closeness, and, consequently, to give more distant planes in the work a sense of being farther away.

2. The color and value of objects in the middle-distance plane that are farther away take on blue neutralized colors. You should also begin softening the contrasts, until you come to the farthest plane.

To perform this exercise, you will need four colors:

MEDIUM YELLOW

CERULEAN BLUE

PRUSSIAN BLUE

OLIVE GREEN

1. Paint the sky with a soft wash of cerulean blue, grading it as you go until you reach the middle of the paper.

1

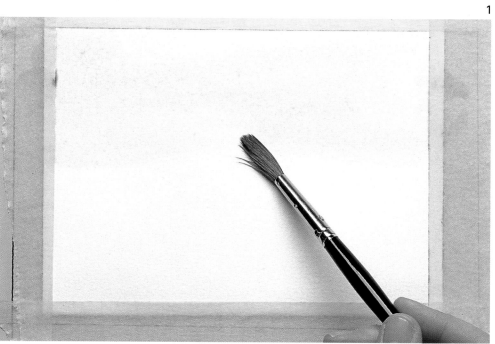

3. In the background plane of a work, contours are hazy, and without any sharp contrasts at all. The actual effect of the world's atmosphere is precisely this.

Painting Atmosphere with Superimposed Glazes

The atmosphere in mountain settings is usually more visible, due to the long distances involved. These pages show a simple way to represent these distances.

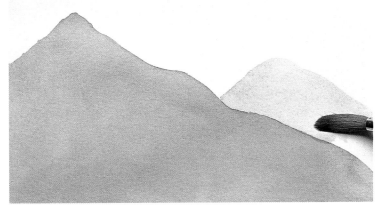

2. On the dry background, paint the largest mountain with cerulean blue lightly mixed with olive green. With the same mixture, but more diluted, paint the more distant peak.

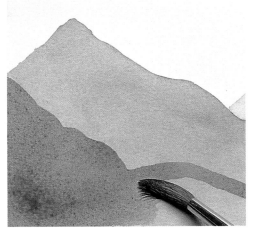

3. When the first two mountains are dry, paint another, using a mixture of Prussian blue and olive green.

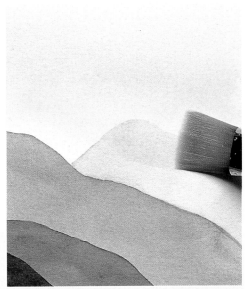

4. To paint the nearest peak, use the same mixture, but much less diluted, in order to make it contrast with the others, and give a sensation of space. Finally, to push the lightest peak even farther away from the viewer, cover it and the sky with a wash of diluted medium yellow, using a medium-sized wide brush.

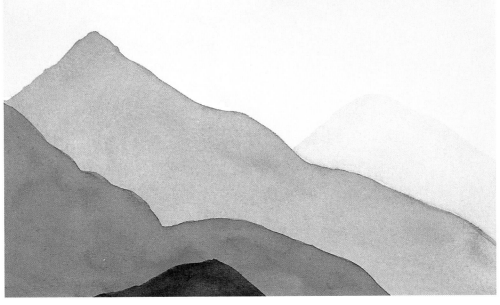

5. We can see in the finished exercise how a homogeneity between the farthest peak and the sky is obtained, thanks to the last glaze, which accentuates the sensation of distance. The peak in the foreground, by contrast, seems quite close to the viewer because of the intensity of color and sharpness of its outline.

Skies

Skies usually complement landscapes and seas, but they can also be the focus of a painting. The form that clouds take on, and the variety of color that can be used to paint them, can make their rendition highly attractive.

To paint a sky like the one on these pages, you will need four colors: cerulean blue, cobalt blue, alizarin crimson, and medium yellow.

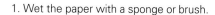

Painting the Sky

Watercolor skies are generally painted using the wet technique because the forms are usually indistinct, and the results of this method are ideal to suggest the fluffiness of a cloud or the gradation of color.

To paint skies using this method, you will need to work rapidly to ensure that the paint does not dry while you are manipulating it, and to control the flow of color.

CERULEAN BLUE

COBALT BLUE

ALIZARIN CRIMSON

MEDIUM YELLOW

1. Wet the paper with a sponge or brush.

2. Paint a graded wash on the wet paper surface with cerulean blue and a touch of cobalt blue.

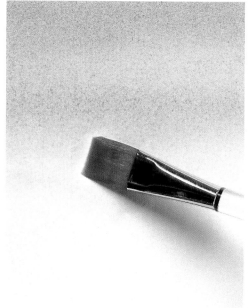

1

2

3

4

6

3. To suggest the whiteness of the clouds, wash a brush in clean water. Supporting the ferrule of the brush on the rim of the jar, let the excess water drip off.

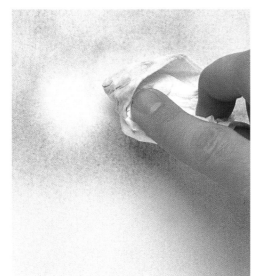

5

7

4. Squeeze out the excess water with a rag, and, brush in hand, make lazy, circular motions on the paper to absorb the wet paint, giving form to the clouds.

5. To obtain a brighter white as contrast, absorb some areas of paint with a tissue.

6. Before the first wash dries, apply another wash with very diluted alizarin crimson, beginning in the middle of the paper and working down.

7. Add some touches of alizarin crimson to the clouds to suggest reflections of rose-tinted light illuminated from below. Now wait for the painting to dry. Afterwards, apply a wash of very diluted medium yellow, making sure to use very little pressure with the brush. You do not want to dissolve the undercoat of paint.

8. You will see that the yellow from this last wash gives the sky the warm tones of an afternoon, as the crimson endows the work with shadings of orange, and the blue with various greens.

8

*W*ater

Water is a liquid whose surface is ever-changing and whose color can vary enormously from one hour or day to the next. Watercolor is an ideal method for giving freshness and spontaneity to whatever scene of water you may choose to paint.

Painting the Sea

The color of the sea depends upon the color of the sky, and the rocks and vegetation beneath its surface. Let us see, step by step, how we paint an image in which the powerful waves of the sea in the background break against the rocks of a small sea wall.

By following this exercise, you will be able to appreciate, through the interplay of colors, the way different shades have been used to suggest the sea from the depths of the background to the coast.

To paint the color of the sea on this gray day, we will use several colors: cobalt blue, sepia, burnt sienna, olive green, and Prussian blue.

COBALT BLUE SEPIA BURNT SIENNA OLIVE GREEN PRUSSIAN BLUE

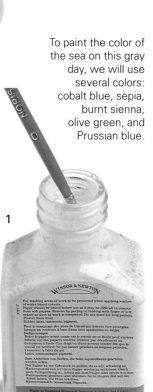

1

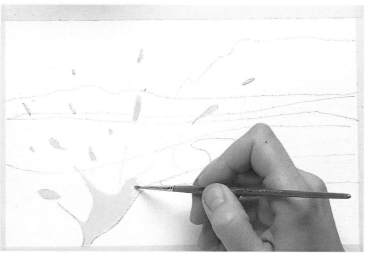

1. Dip an old brush into masking fluid.

2

2. Paint the masking fluid onto the area that corresponds to the foam of the wave that is crashing against the sea wall. This will preserve the white of the paper.

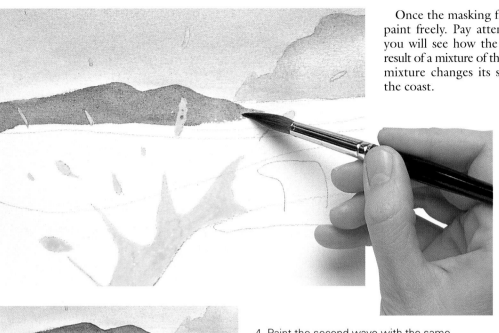

Once the masking fluid has dried, you can paint freely. Pay attention to the mixtures: you will see how the first color used is the result of a mixture of three colors, and how that mixture changes its shade as it approaches the coast.

3

3. After painting the sky with cobalt blue, and the cliffs with sepia and olive green, paint the wave farthest away with a Prussian blue slightly tinged with olive green and some cobalt blue, so there is a certain similarity with the sky.

4. Paint the second wave with the same mixture, but more diluted, and with a larger proportion of olive green. Add some strokes on the wet paint with a mix of burnt sienna and sepia to suggest seaweed floating on the water surface. Paint the next wave with the same mixture, but even more diluted.

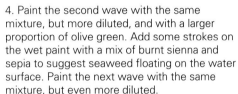

4

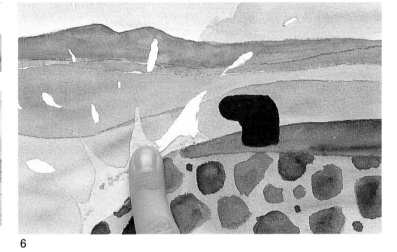

6

5

5. To this last wave add some cerulean blue and dilute the mixture even more to lighten the value. You can paint right over the masking fluid without concern.

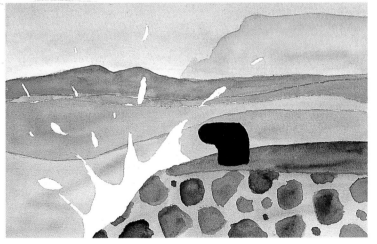

6. When the paint that suggests the sea is dry, paint the sea wall with burnt sienna, and the rocks with sepia. The pylon is painted with ivory black. When all of this is completely dry, you can remove the masking fluid with an eraser or your finger. You will notice that the area of white paper has remained intact.

Vegetation

Almost any countryside has a variety of vegetation; from the soft grasses of a prairie to the dark leaves of a tree in shadow, the range of greens that you think you will need may seem hopelessly wide.

To paint the vegetation of this landscape we have used the three greens from the palette that this book recommends: permanent green, olive green, and emerald green. We also made some mixtures using sepia and medium yellow.

Painting a Landscape

This simple landscape is made up of distinct types of vegetation; a meadow, some trees, and a luxuriant forest in the background. Each type of vegetation is a different shade of green.

In this exercise, we will see that, even though only three greens from the palette were used, not one of them was applied directly. Examine the greens of the foreground for a moment. They have been shaded with a touch of yellow. In this way, we have unified the foreground. The mountain in the background does not contain any yellow and it becomes separated from the foreground, accentuating the sensation of distance.

1. Paint the sky with a soft wash of cerulean blue and proceed to suggest the small meadow with permanent green mixed with a small amount of yellow.

| PERMANENT GREEN | OLIVE GREEN | EMERALD GREEN | SEPIA | MEDIUM YELLOW |

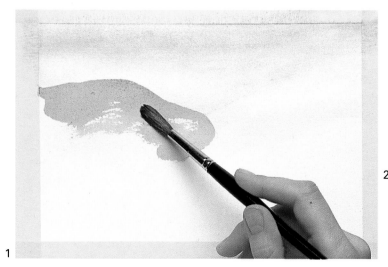

1

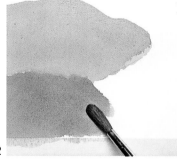

2

2. Paint the mass of a tree with olive green slightly brightened with a touch of yellow, before the paint of the meadow is dry, so that both mix softly and the tree does not break sharply along its edges.

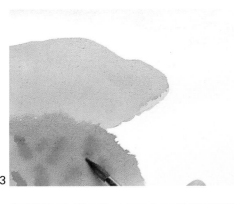

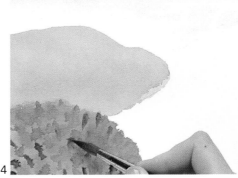

3. While still wet, begin to paint the foliage with small strokes of emerald green.

4. After this, add some touches of strong olive green to the tree's foliage.

5. Next, paint the road along the cliff with ocher and burnt sienna. Suggest the wall of the cliff with sepia. Paint the trees on the meadow with olive green mixed with some yellow.

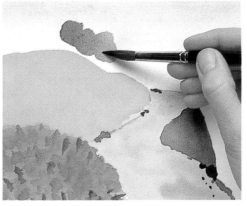

6. With the same mixture, paint some small shapes to suggest shrubs and weeds. Give some of them touches of color like alizarin crimson to imply flowers.

7. Paint the mountain in the background with a mixture of olive green and emerald green. Play with the wet areas to create smudges and smears so the mass won't be a flat surface.

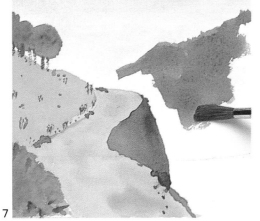

8. Wash the brush, and dry it on a rag.

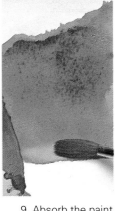

9. Absorb the paint at the bottom of the mountain, so that you can later add some small brushstrokes of sepia. In this way, the vegetation and the rocks are gradually integrated.

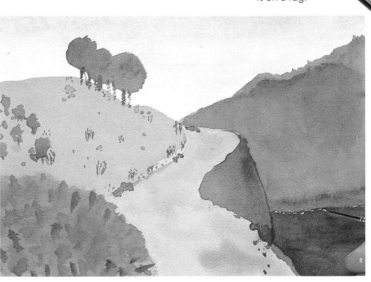

10. After painting the water with Prussian blue and letting the paint dry, load a bit of Chinese white on a fine brush.

11. To finish up, add some touches of white along the water's coastline to suggest waves.

Flesh Tones

Human skin presents a whole range of color and value that make it an appealing subject for watercolor painting. For this reason, painting flesh tones can be an interesting challenge for the beginner.

To paint this baby's bottom we have used alizarin crimson, burnt sienna, ocher, and orange.

Painting Skin

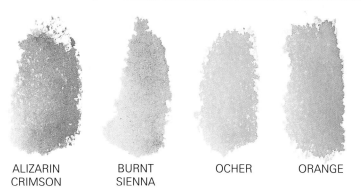

| ALIZARIN CRIMSON | BURNT SIENNA | OCHER | ORANGE |

For those who are beginning to paint in watercolor, human skin tones can be a challenging puzzle. When the time comes to paint a torso, a leg, or an arm, one glances at the palette and wonders which is right for flesh tones. The truth is that human skin is never just one color. The color and texture of skin can only be reproduced through mixtures of colors.

Warm colors such as reds, crimsons, earth tones, and yellows are mainly used for skin tones, although many times an artist will use blues, which are cool, to suggest shadows.

1

1. Cover the entire area of the body with a soft wash of a very diluted mixture of ocher and orange.

2. Intensify this tone by adding a touch of crimson and some burnt sienna, and paint the darker leg, making sure that some of the paint accumulates along the edge of the buttocks. Water down this mixture and paint the area of the flank.

2

3. Soften the edges of this last wash with a wet brush.

3

4

4. Look at the painting for a moment. Here, the value of the shadow of the buttocks needs to be darkened. For this, use some burnt sienna to touch around the edges while the previous glaze is still a little wet. This way, the paint will softly flow and blend, and not produce any breaks.

5

5. Next, apply another glaze with the same mixture, but more diluted, to suggest the shadow of the flank.

6

6. To finish, soften the lines of the edges with a glaze of very diluted orange.

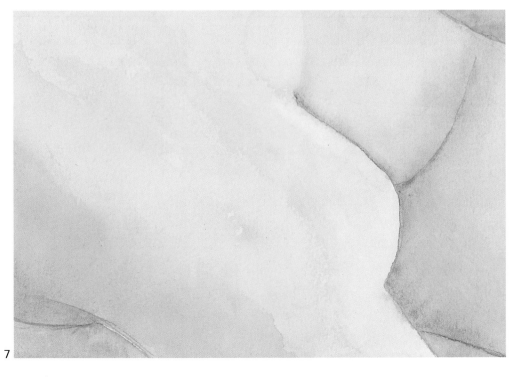

7

7. In this exercise, you can see that the initial glaze was painted to establish the skin color. Later on, step by step, you learned that the skin color was improved by playing with four colors, and that the skin tones were suggested by successive glazes.